Serpent's Chronicle

Serpent's Chronicle

Neil Folberg

Foreword by Joseph Skibell
Afterword by Allen Hoffman

Abbeville Press Publishers
New York · London

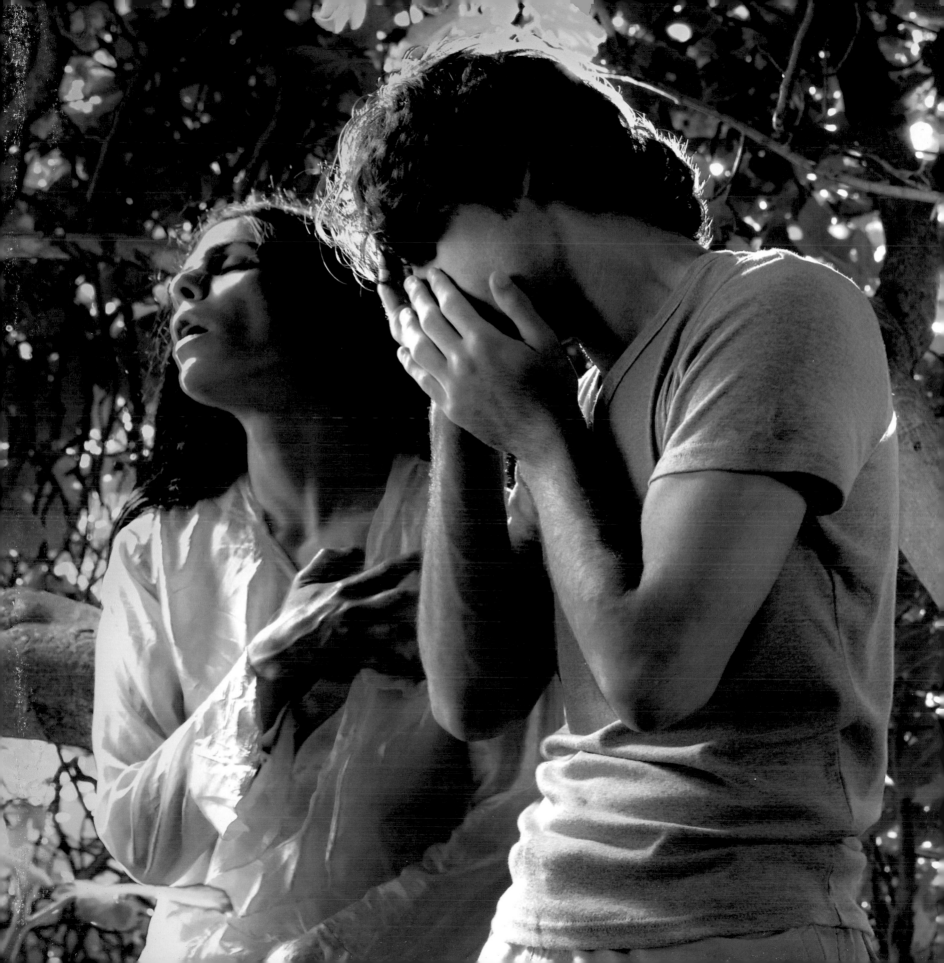

Foreword

By Joseph Skibell

Unlike the Church Fathers, who would call the first book of the Bible Genesis, or *Origins*, the Jewish sages entitled it *B'reshit*. And from the very beginning, commentators have pointed out the ambiguity in this name. Though *In the beginning* is a perfectly respectable translation, *With a beginning*—as in *With a beginning, God created Heaven and Earth*—offers the mystic, as well as the storyteller, a thicker interpretative stew.

In the *Book of B'Reshit*, there is no origin. As even an inattentive synagogue-goer knows, according to *Adon Olam*, the song in praise of the Holy One that starts the liturgy, God is *b'li reshit*, without a beginning.

In other words, In the beginning, there was no beginning, and along with everything else, it was necessary for God to create one, which He did, fabricating it, I suppose, out of the same materials He had on Hand for the Heavens and the Earth: *tohuv'vohu v'chosekh*—chaos, desolation and darkness—the materials artists use in their work to this very day (along with light, if, like Neil Folberg, you're a photographer).

Having fabricated a beginning, the Lord saw that it was good, and He gave one to every human being. Not that it did us any good. As a close reading of the *Book of B'reshit* reveals, we're not meant to stay in one place. Man is a traveler, and our beginning is not so much a point of origin as a point of departure. The *Book of B'reshit* is, among many other things, a compendium of various archetypal modes of leave-taking.

There are many ways to take one's leave: Abel disappears like a sigh; Noah is tossed upon a storm; Abraham told to go forth for himself; Isaac offered up as a sacrifice; Jacob chased out of town; Joseph thrown into a pit, sold into slavery, imprisoned and ultimately redeemed. On the other side of the family tree—the *sitra achra*—a certain lack of favoritism sends us on our way: Ham is cursed by his father, Esau feels cheated, Joseph's brothers feel unloved.

Exile, of course, is perhaps the most ancient way of venturing forth: Hagar and Ishmael are cast out, Cain wanders the plains of the earth as an outlaw. And then there are Adam and his Eve, the mother of all life, and their expulsion from Eden, the mother of all expulsions.

Life is a trap, a trick, Folberg writes in his gorgeous photo-narrative, *Serpent's Chronicle,* and there are many ways to understand this. From Adam's point of view, one must

be tricked into life, seduced and beguiled. Enticed by physical temptations, the soul becomes entrapped in the body, and as a corporeal being must labor to bring forth life and to stay alive.

But it's all a trick, played on us by a loving Deity, for our own benefit. To paraphrase Folberg's serpent, we weren't meant to remain immortal. That which has not been separated cannot be united, and somehow love exists only outside the garden wall.

These trumped-up beginnings are an even deeper trick. More than tricked into leaving home, the exile gets trapped in his beginnings, believing that they somehow define him. This is nonsense. As we've seen in the *Book of B'reshit*, the Holy One creates Heaven and Earth with a beginning, but He might as easily have created them without one. At heart, it was an aesthetic choice, required, to some degree, by the invention of time.

But there's no reason to imagine that our beginning is the most real part of our life, though it often feels that way. There's no reason to believe that our beginning defines us. The model of Abraham, summoned from his home by divine decree, offers a gentle corrective to this view: where we're going is more defining than where we come from, and in the end, all that really matters is our wandering, the work of our getting there, wherever there is.

Now, the serpent sometimes lies, it's true, but not always. A liar who lies all the time will deceive no one eventually, and the last words Folberg coaxes from his serpent's forked tongue are true: *Only my chronicle remains.*

Our beginning is something the good Lord made out of nothing—to tell you the truth, most of us don't even remember the first years of our life—but the story we make of those lives, the yarn we spin out of that imaginary beginning, the chronicle we shape and author, the art we make of ourselves, will remain long after we disappear again into the imaginary.

With an eye sharpened by light and a heart deepened by *midrash*, Neil Folberg captures these truths in a photo-narrative that is, at once, beautiful and tragic.

N o one sees me moving in the grass, though I see all. The grasses, trees and flowing water in my garden encompass all existence and every instant.

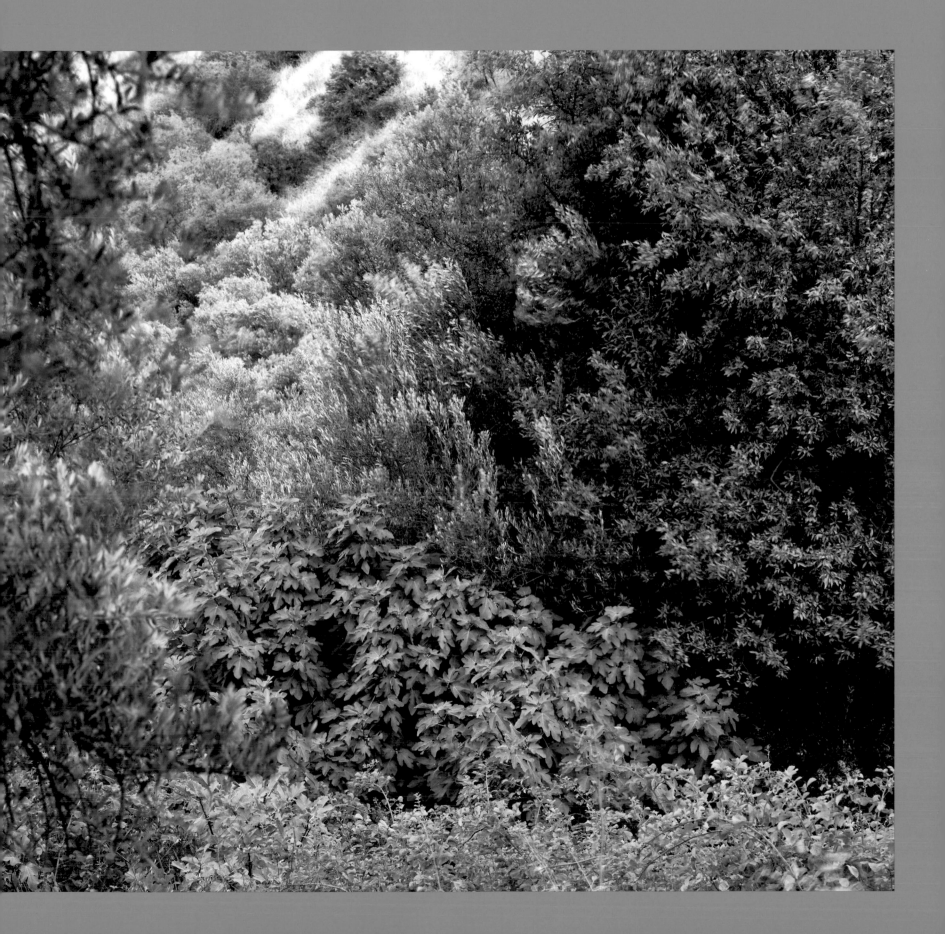

A tree, finer than all others, spreads its roots
toward the water that bubbles to the surface. This
tree has many trunks that grow in a dense, sinu-
ous tangle beneath a canopy of leaves through
which penetrates a light blinding in its brilliance.

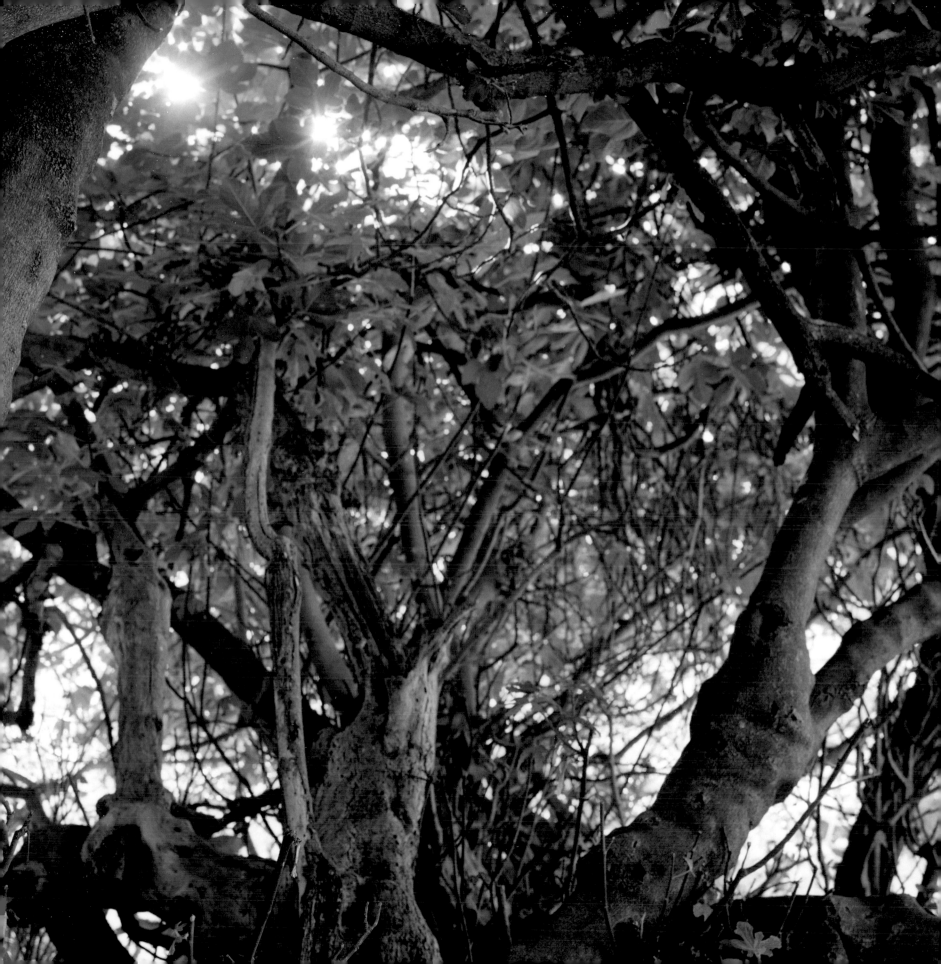

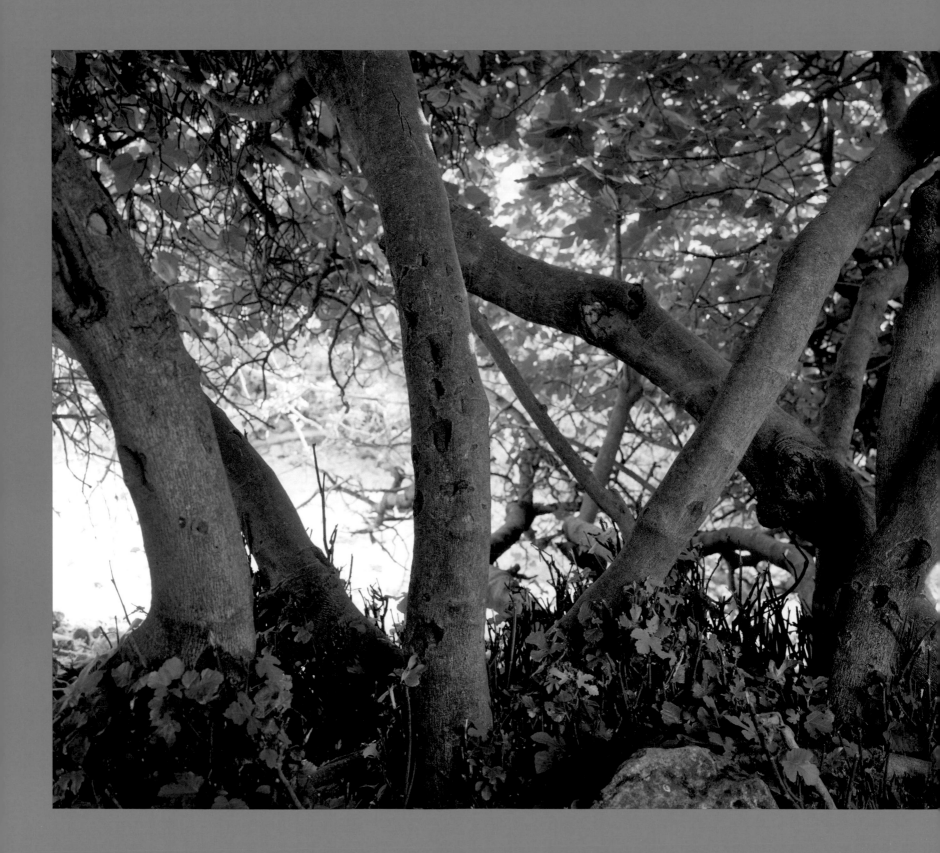

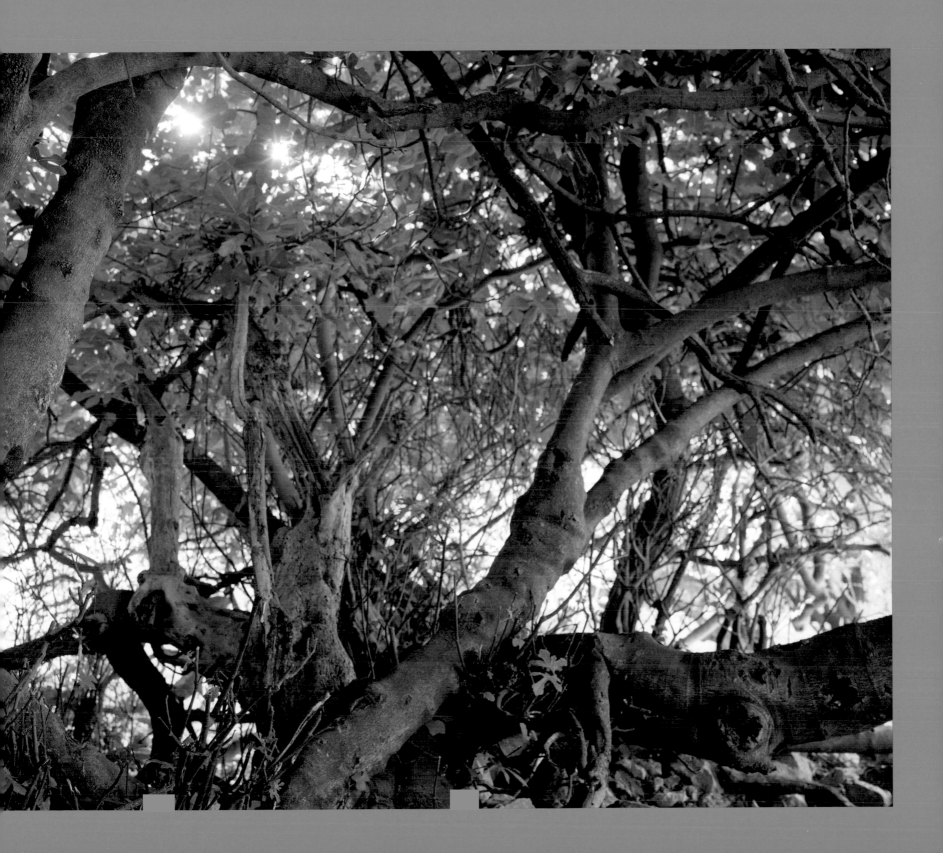

Fallen fruit with tinges of red and even redder fruit with hues of green open to reveal the sweet crimson blood of the universe. The sweetness exceeds imagination and fills my senses with longing for more. I lift my eyes in search of other sweet fruit and for an instant, I can see from one end of the world to the other, from the present throughout eternity: I can see you.

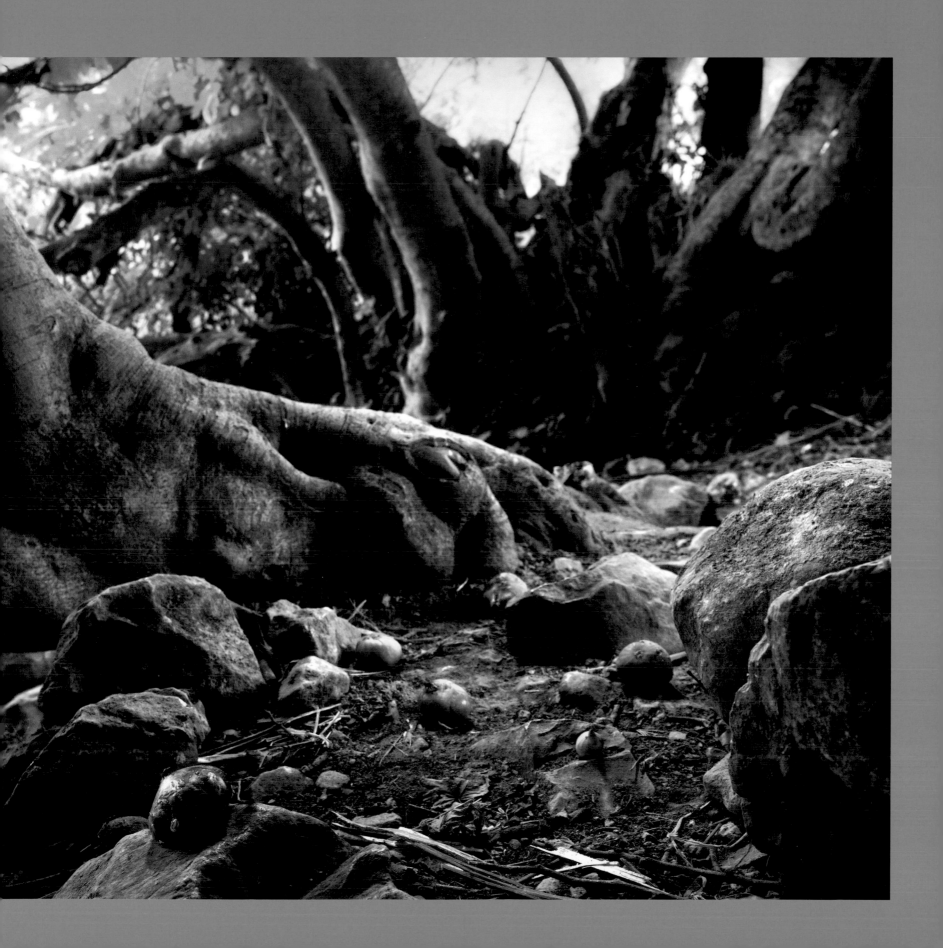

A golem, an embryonic man, lies before me.
Even his heels glow brighter than the sun: if
he were to step on me, he would burn me.

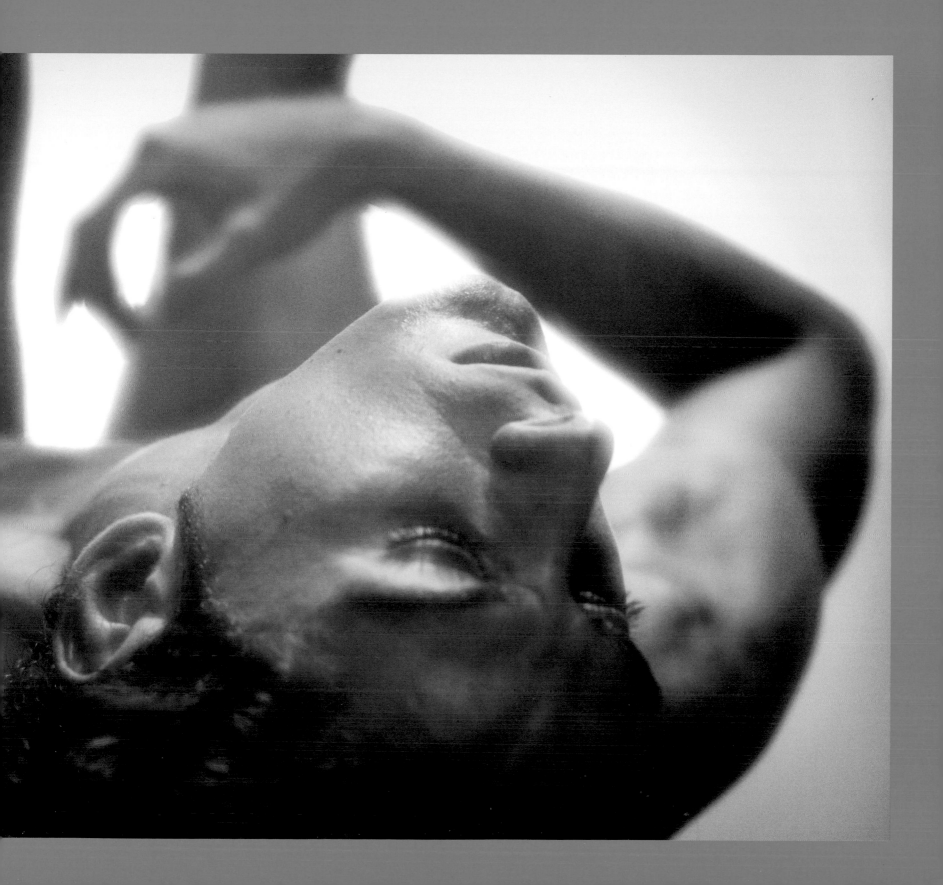

The golem awakens and a man rises. As the man moves through the garden he looks for a companion.

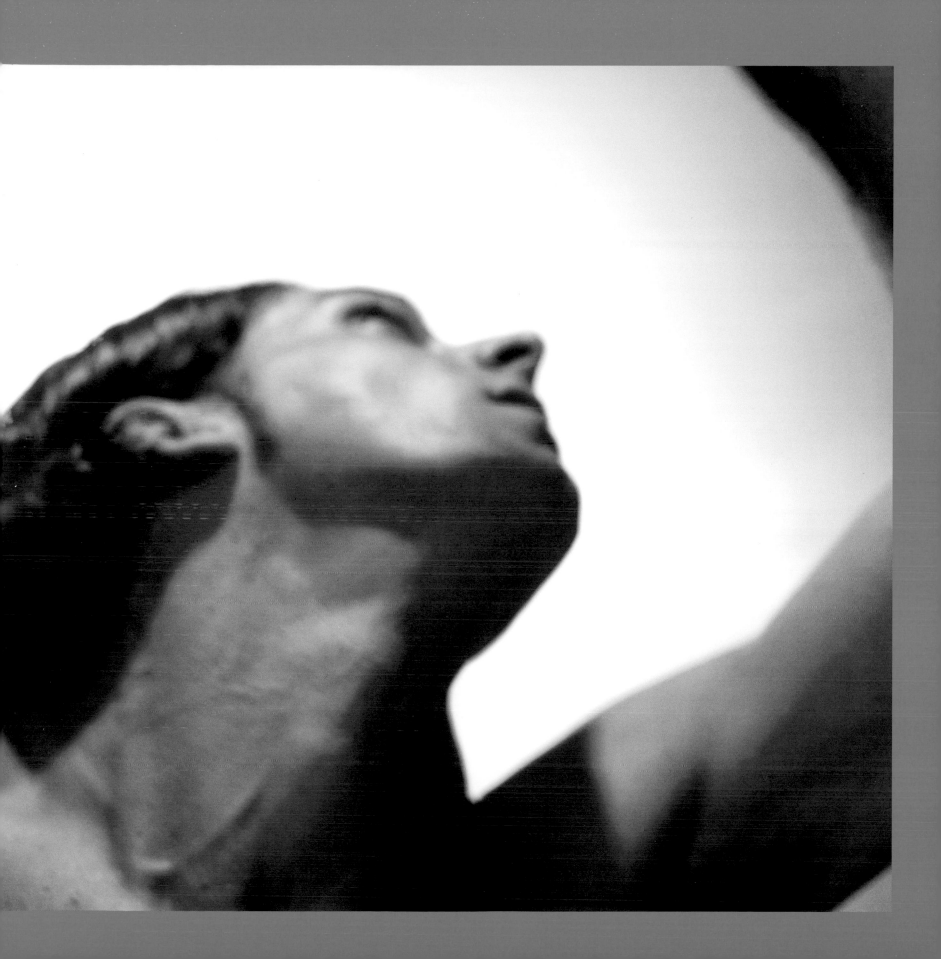

To satisfy him a woman takes form, her head joined to his, back to back, one creature at first. Sundered apart, each now contemplates the existence of the other.

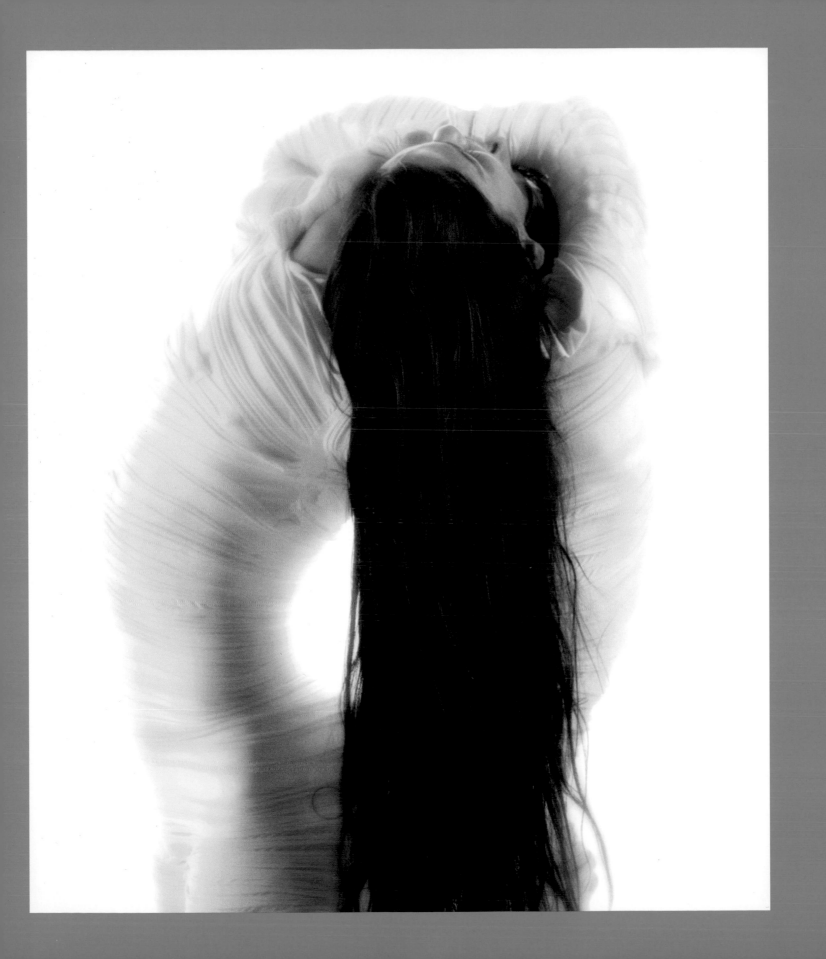

As they walk through Eden, Adam warns Eve of the tree they must not touch and pronounces the names of all creatures. Though I would wish to remain invisible, he calls me, the serpent, "Nachash," a mysterious name, sinuous in sorcery and serpentine cunning.

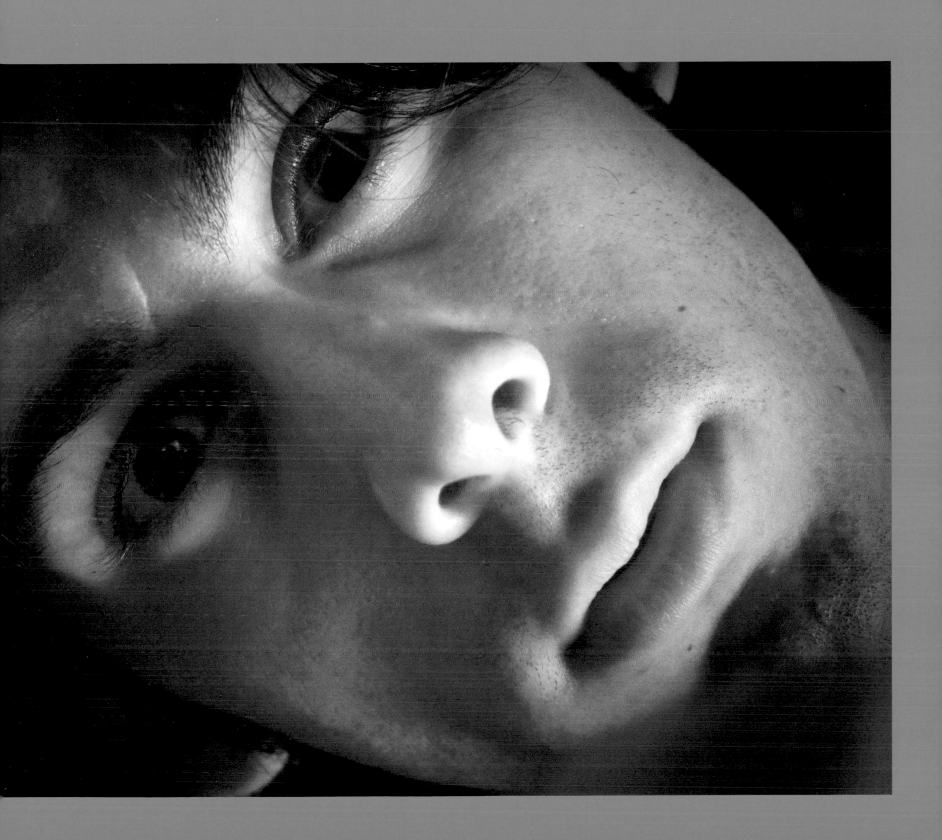

I watch as they reunite.

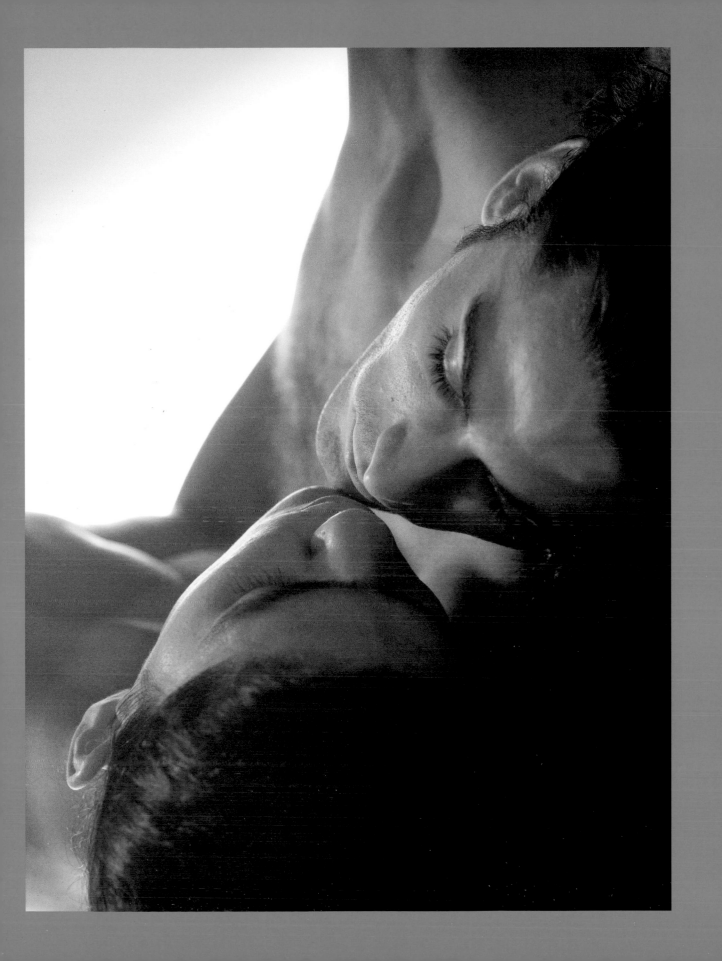

Then while he sleeps, she explores the
forbidden tree.

Adam believes that Eve is his alone, but
I can see that her gaze is not only for him.
I hang unseen among the tree's branches, a
branch laden with fruit. Ripe figs with the
fragrance of sunlight cast a spell. Her hair be-
comes tangled in the branches and . . .

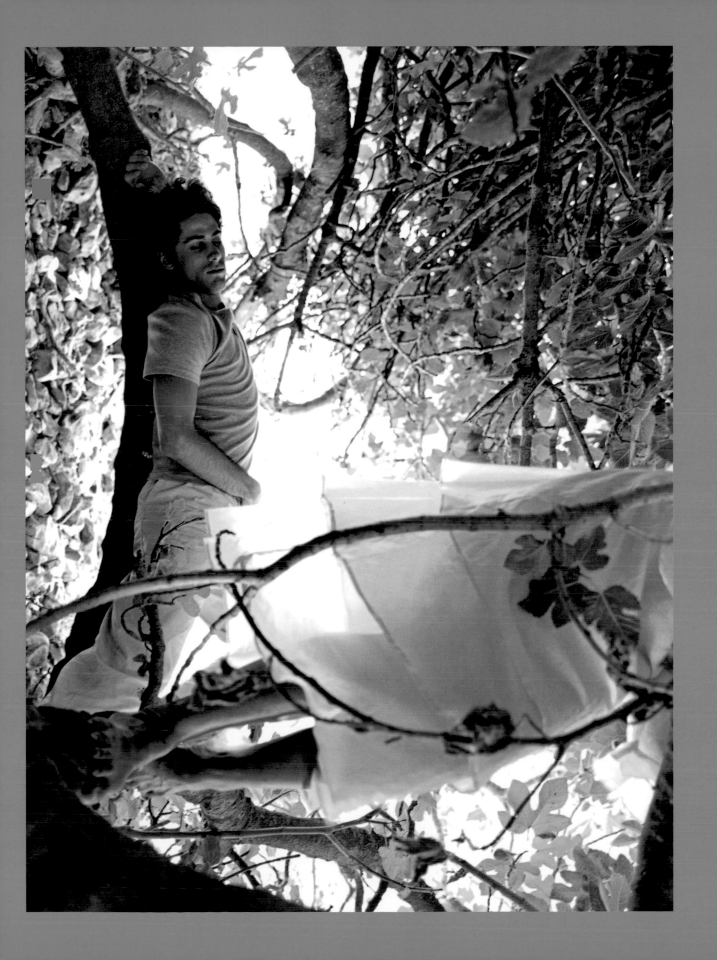

. . . a fig falls loose before her.

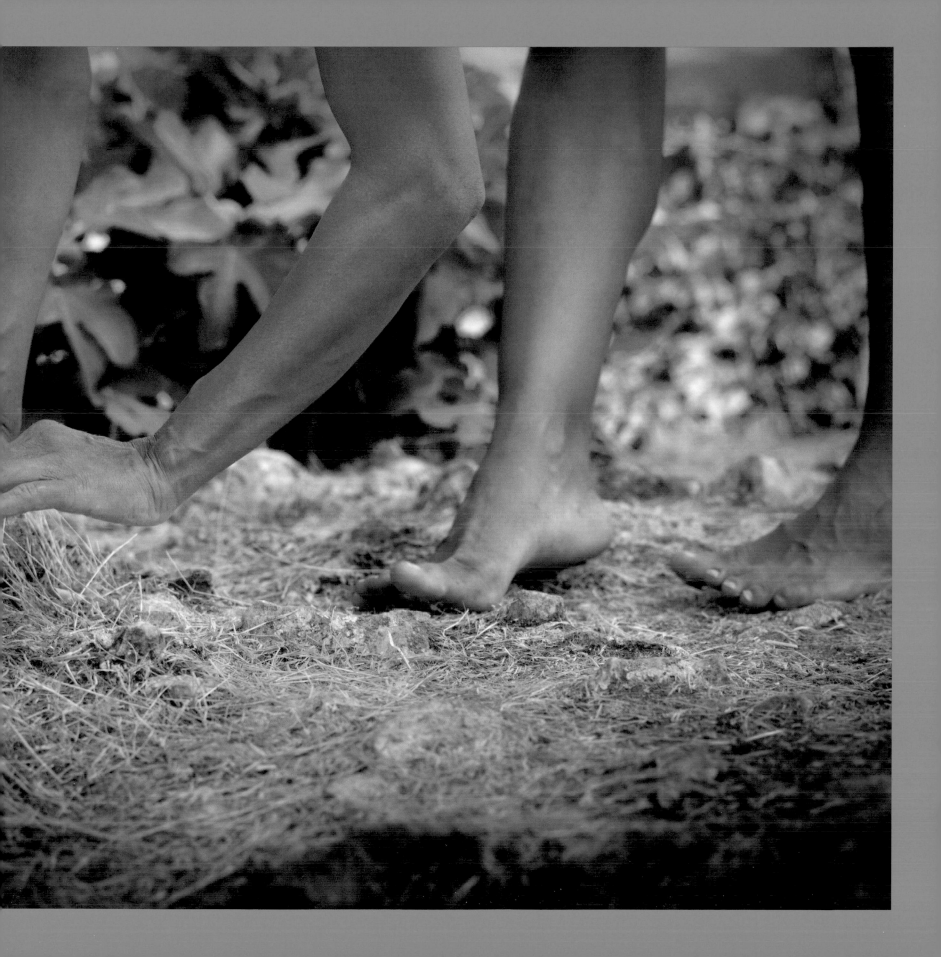

Fig leaves, with fingers like hands, caress her face. If she ate the fruit what would she see?

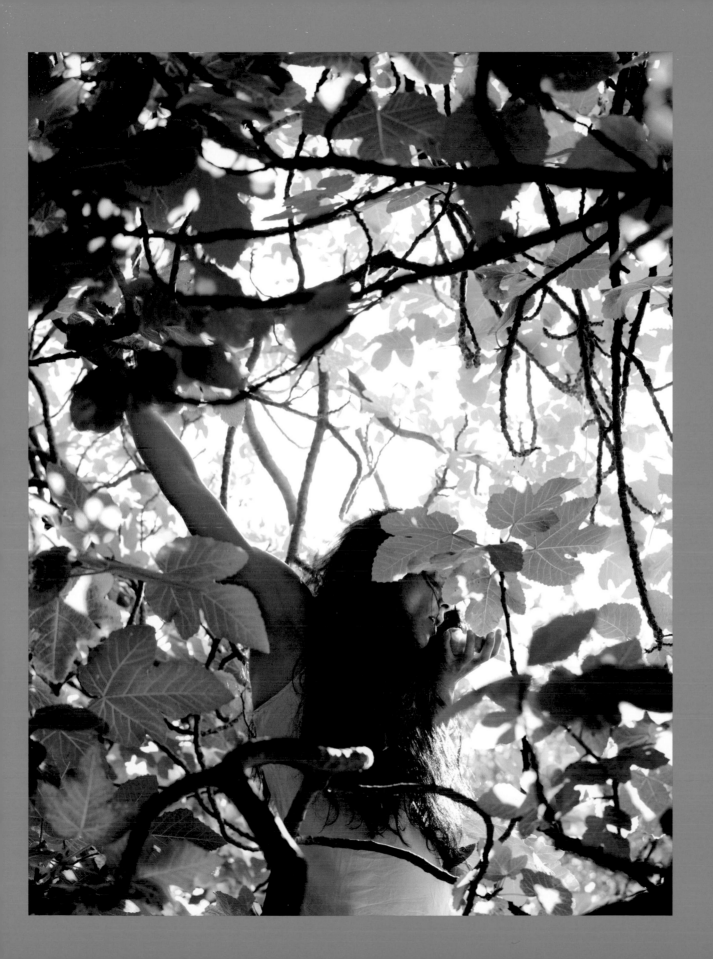

She would see the flow of life unfolding; she would offer a prayer for her descendants. I know the taste of destiny and think them foolish for abstaining from such sweetness. The warm fragrance of ripeness seduces her. She licks the sticky syrup from her fingers, and as she eats, her eyes gaze upon a new world rich with possibility and despair, where death conquers birth and birth cycles in endless pain.

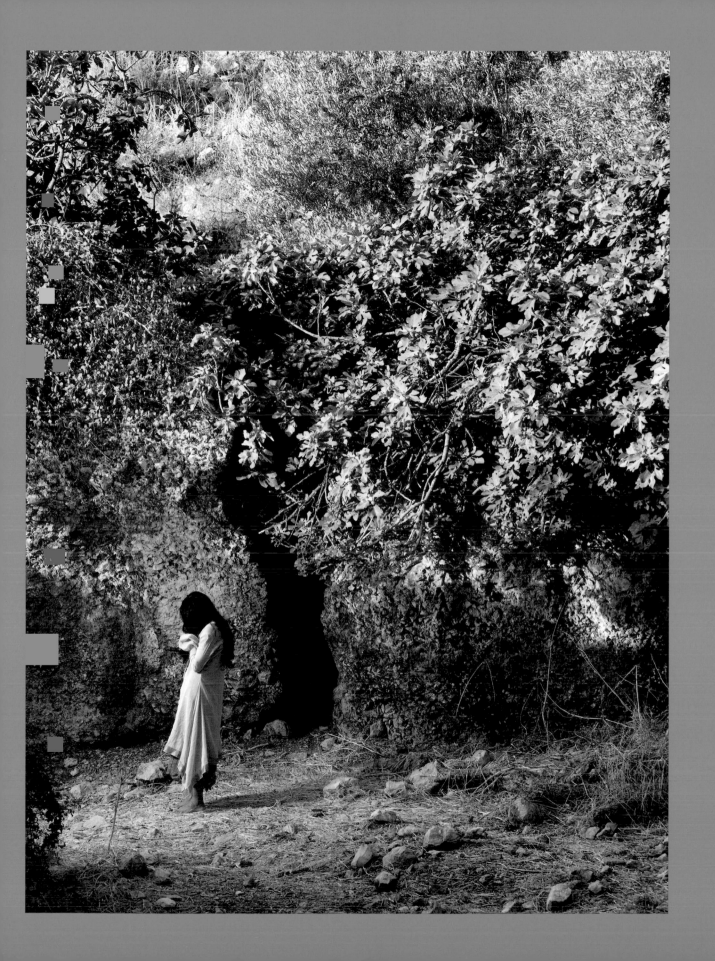

Life is a trap, a trick;

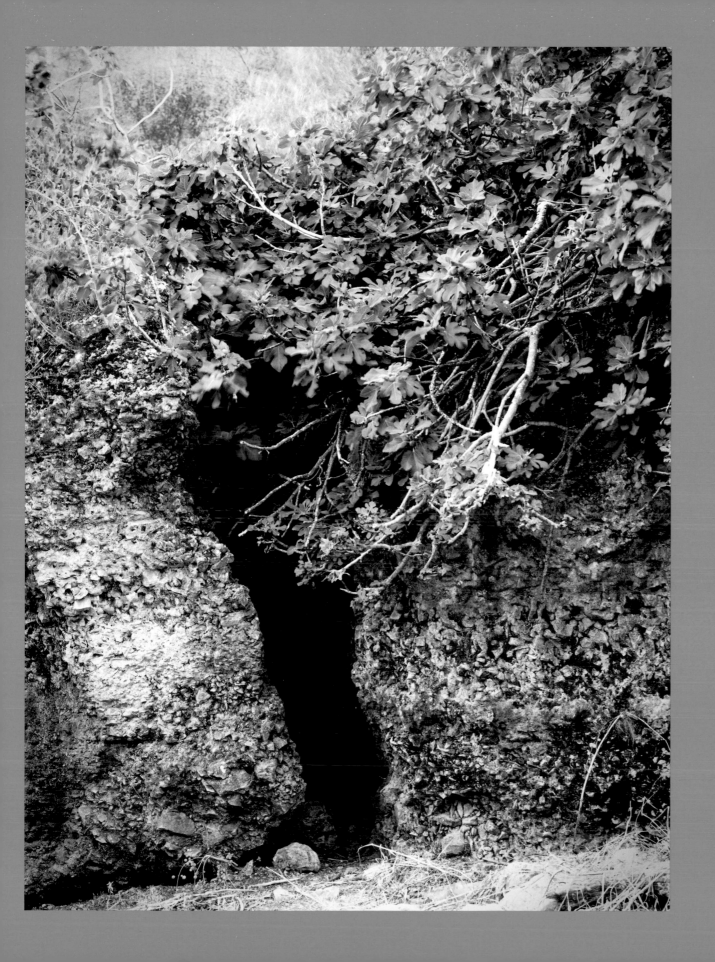

Eden, a dream.

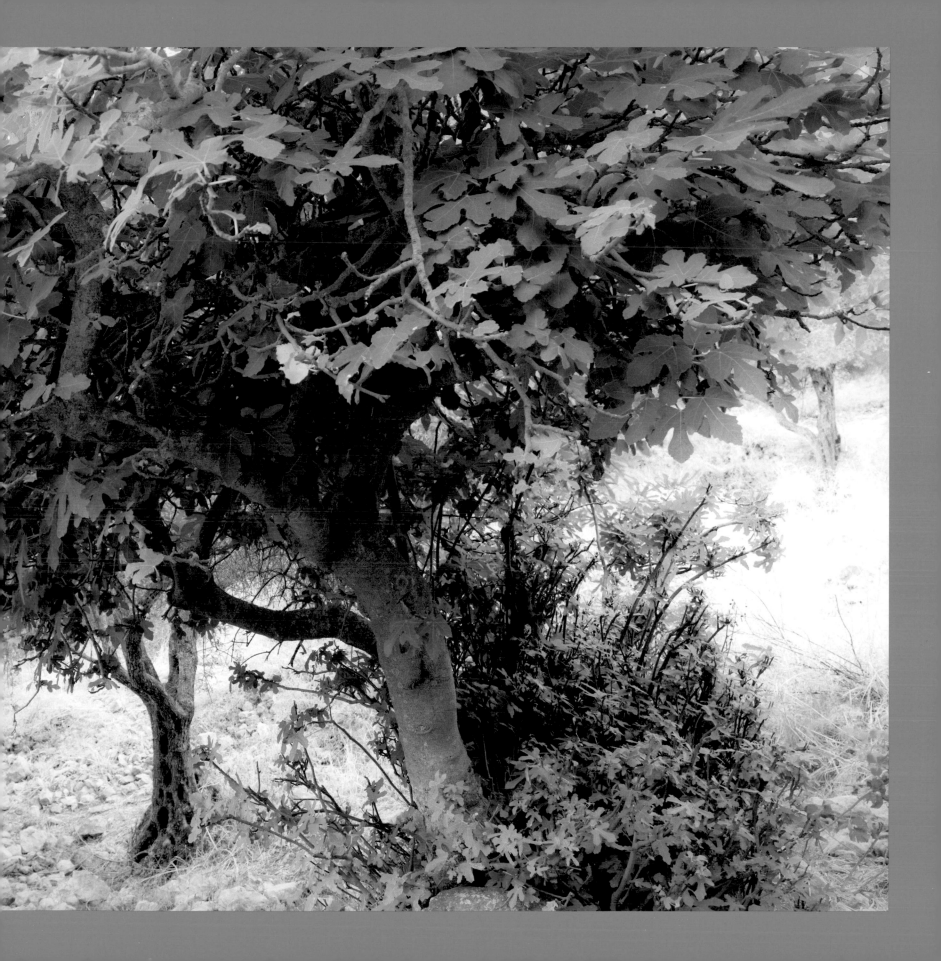

Along with mortality, Eve has acquired cunning. She fears that after her death he will forget her and desire another mate.

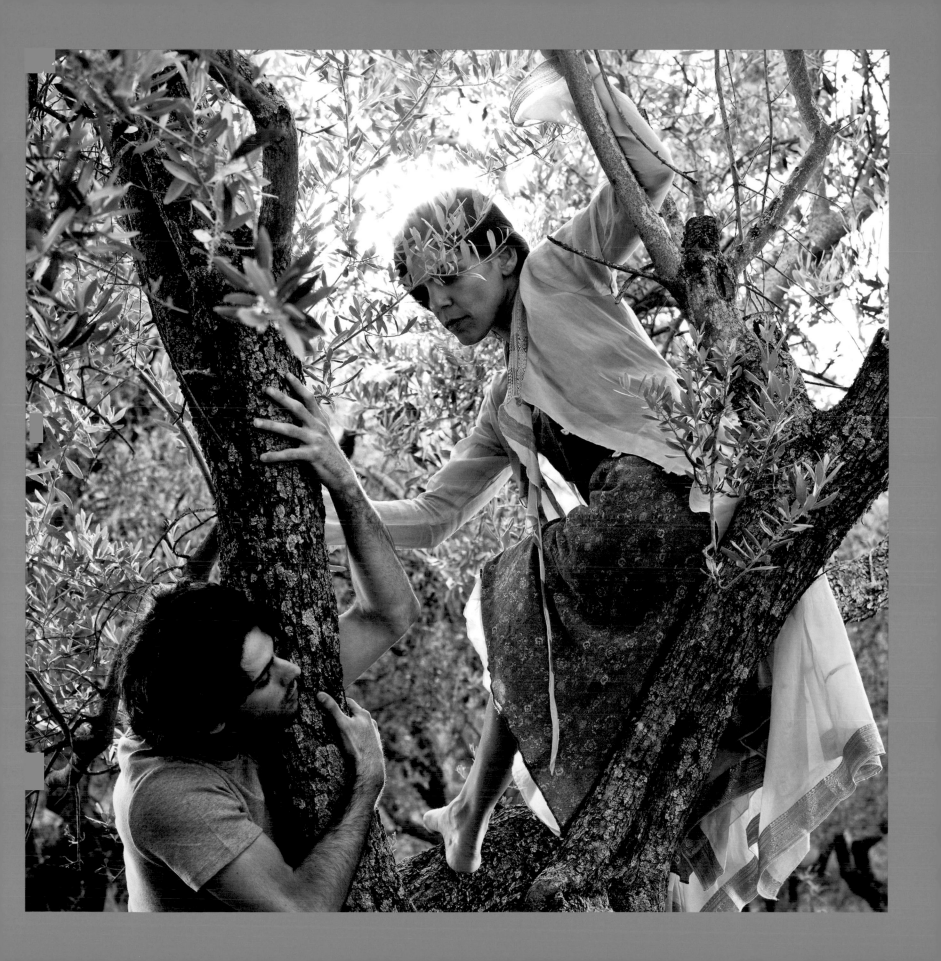

Offering him fruit, she whispers to him.

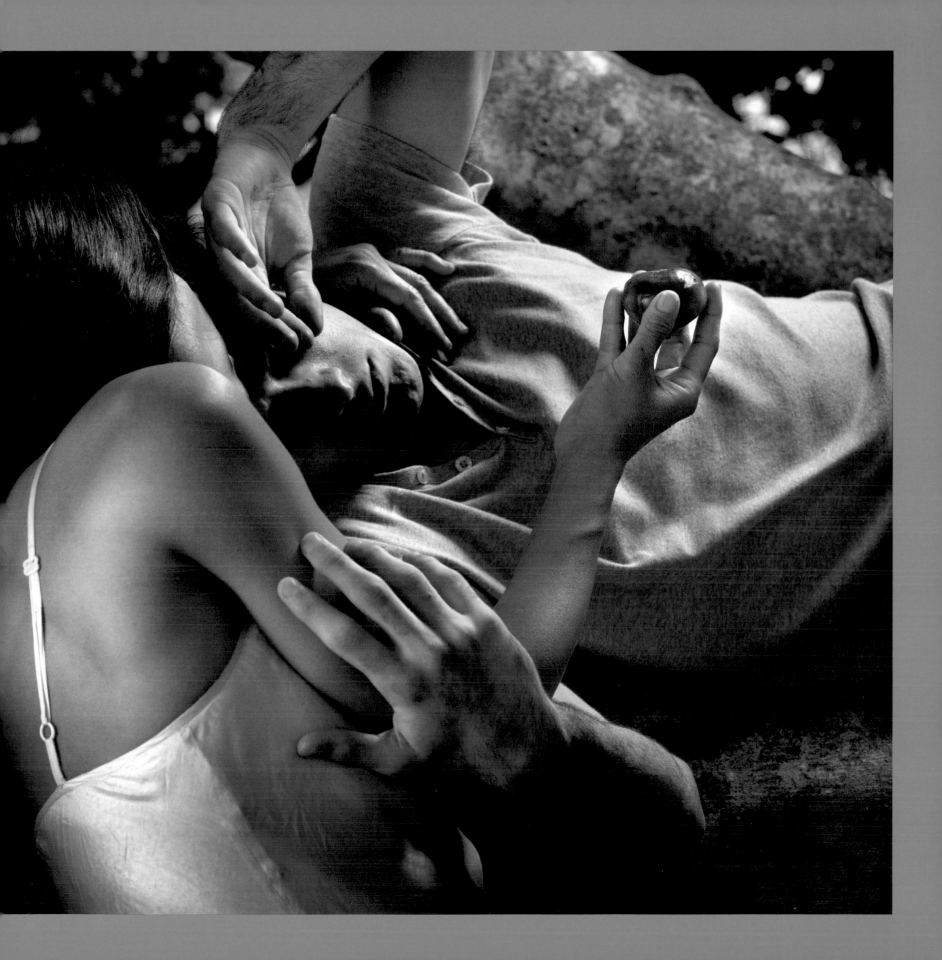

Should he hesitate she will thrust him
into the tree.

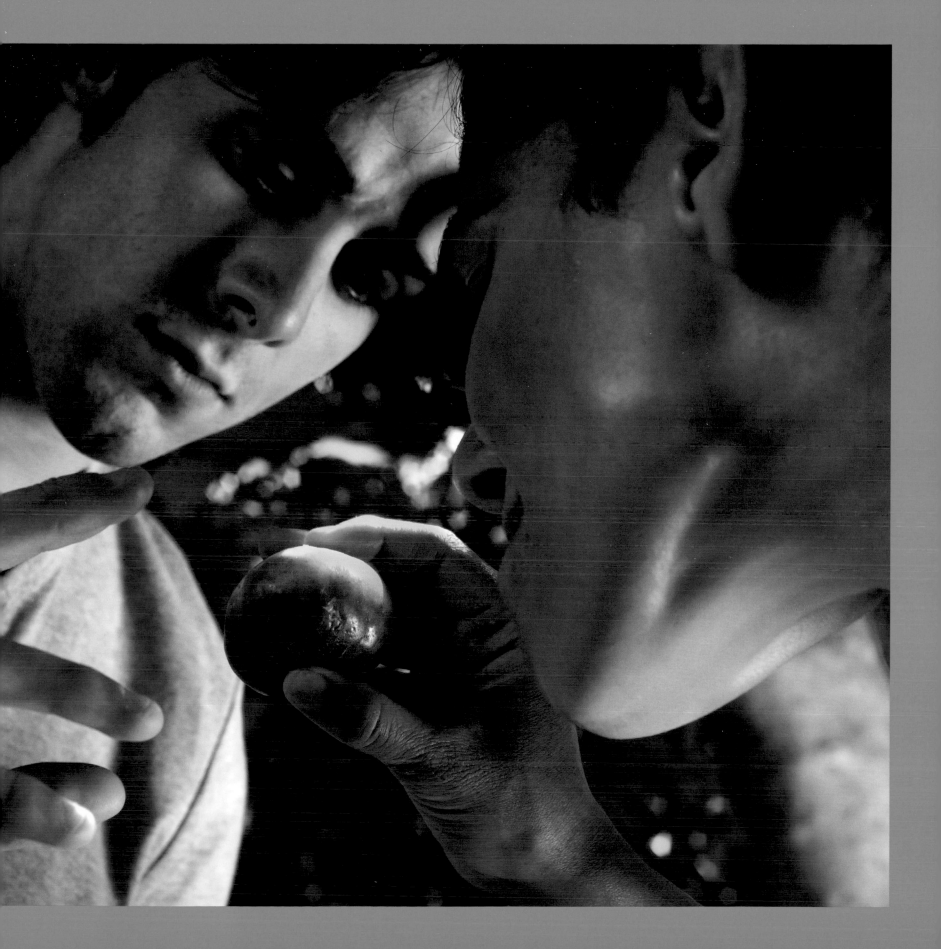

Awaiting exile or death, they shudder in the
light of judgment, but time continues and for
the moment nothing happens. They might
blame each other for a shared fate, or perhaps
they have accepted the struggle to survive in
the exile that is your world.

As the sun melts beneath the horizon, the seventh day commences. Even the darkness is filled with light and spirit imbues the physical. This luminous darkness will henceforth be hidden until the end of time. Shadows glow and doubts dissolve in life's nebulous corners.

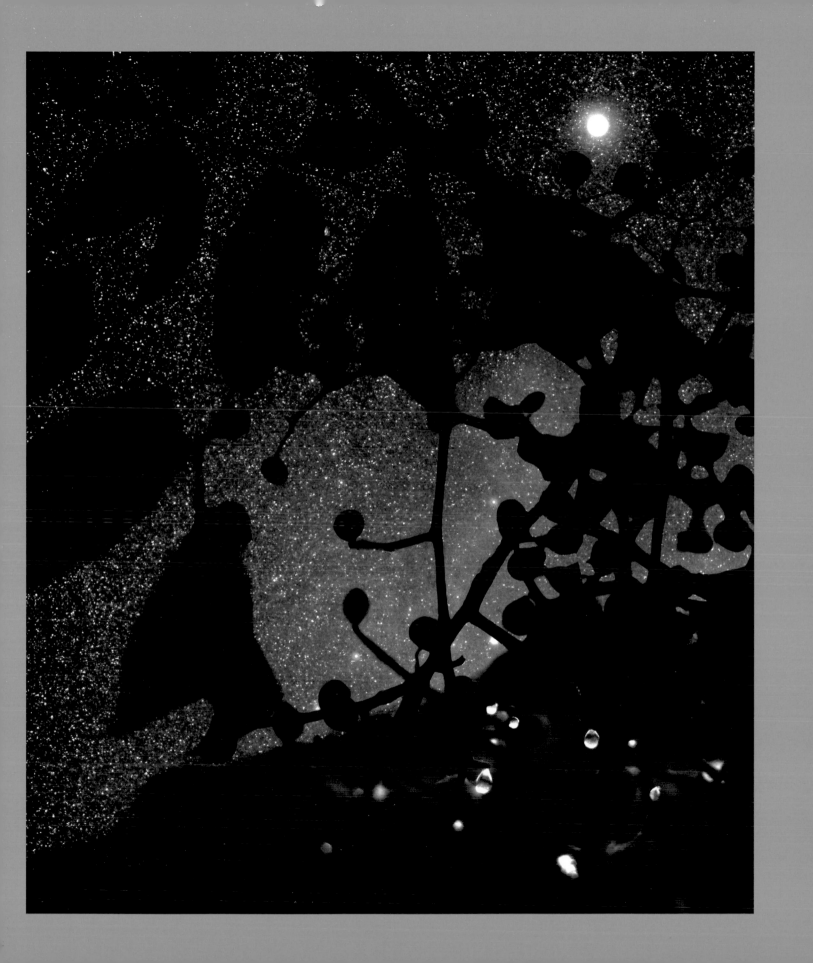

Stars of the cosmos limn the ends of
the universe.

Apprehension of exile slowly dissolves in the new day that blazes with warmth. Earlier, he needed her; now, they need each other.

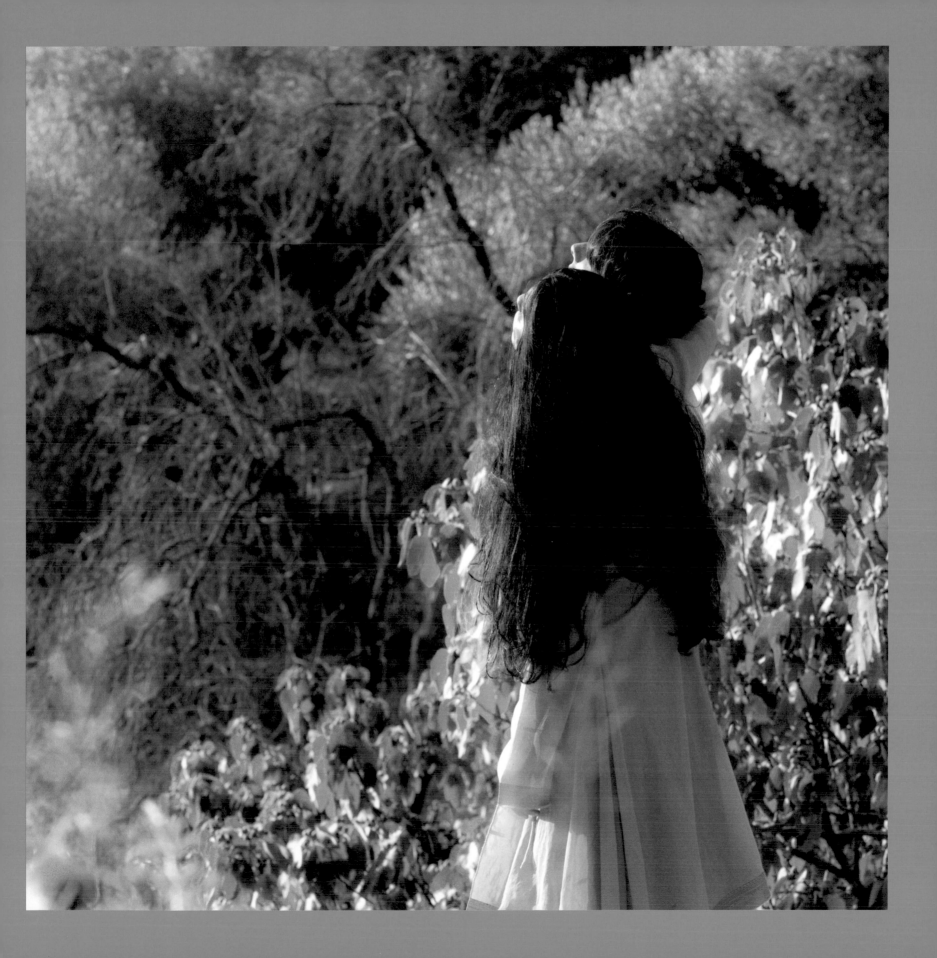

On the second eve, shadows darken as fear surrounds them.

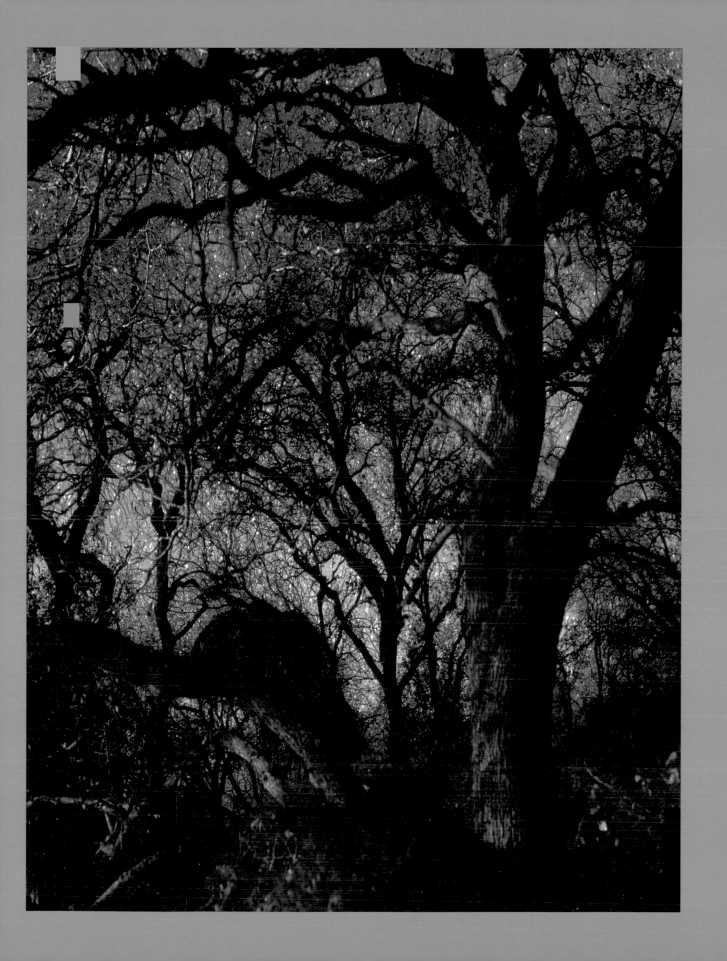

Adam kindles a fire to dispel the doom
only to expose their own fear and wonder in
the darkening gloom.

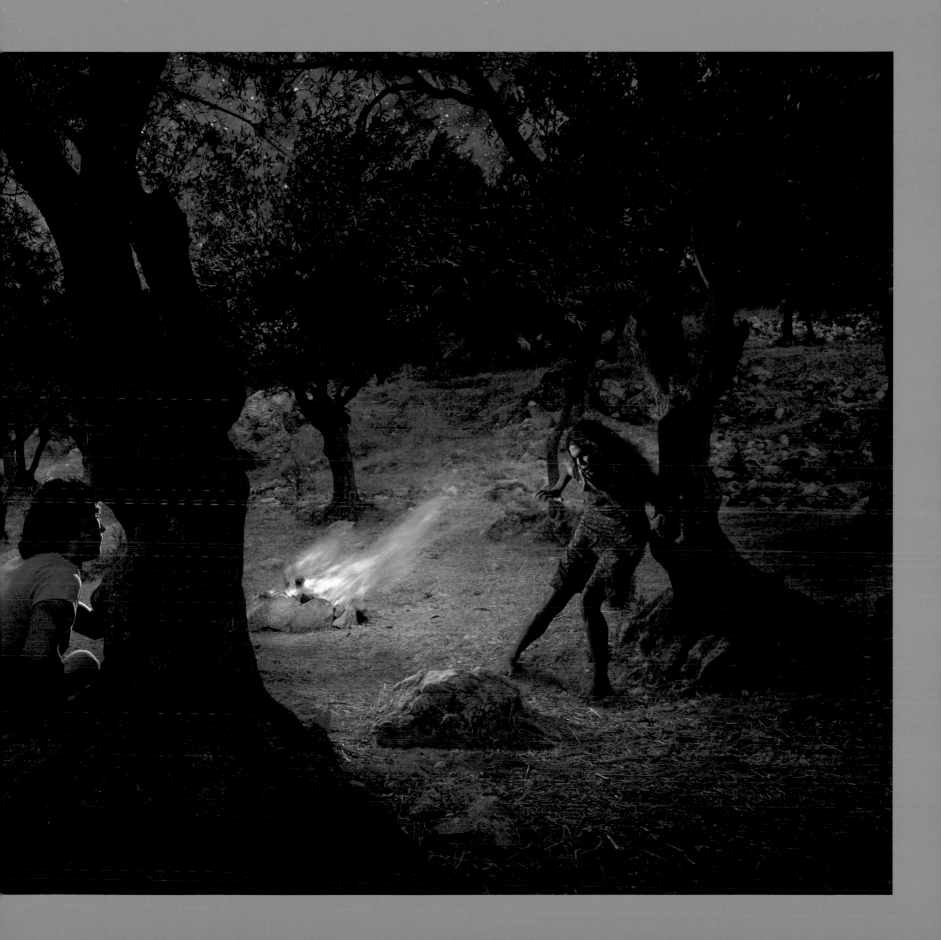

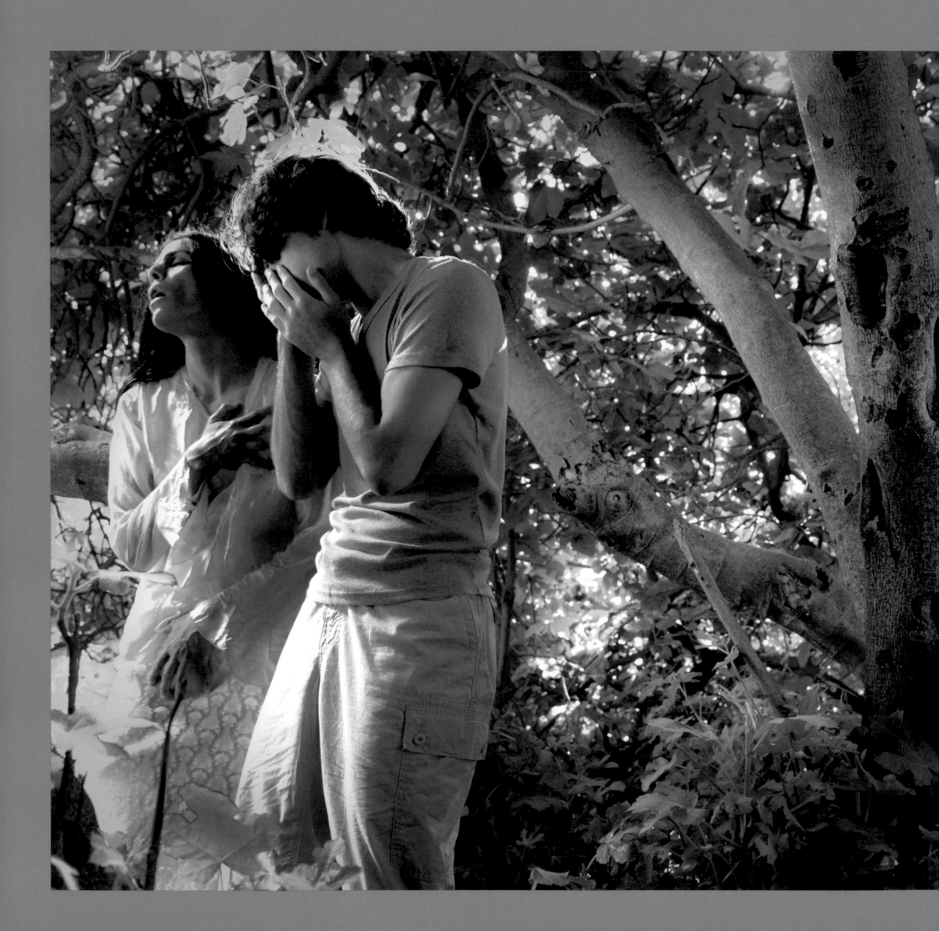

Exile arrives at dawn as they are chased and pursued from the garden. They flee through the trees and brush toward the river that borders Eden.

The light of dazzling diamonds that refracts
Eden's luminescence captures their vision. To
retain this glittering existence, Adam seizes a
diamond . . .

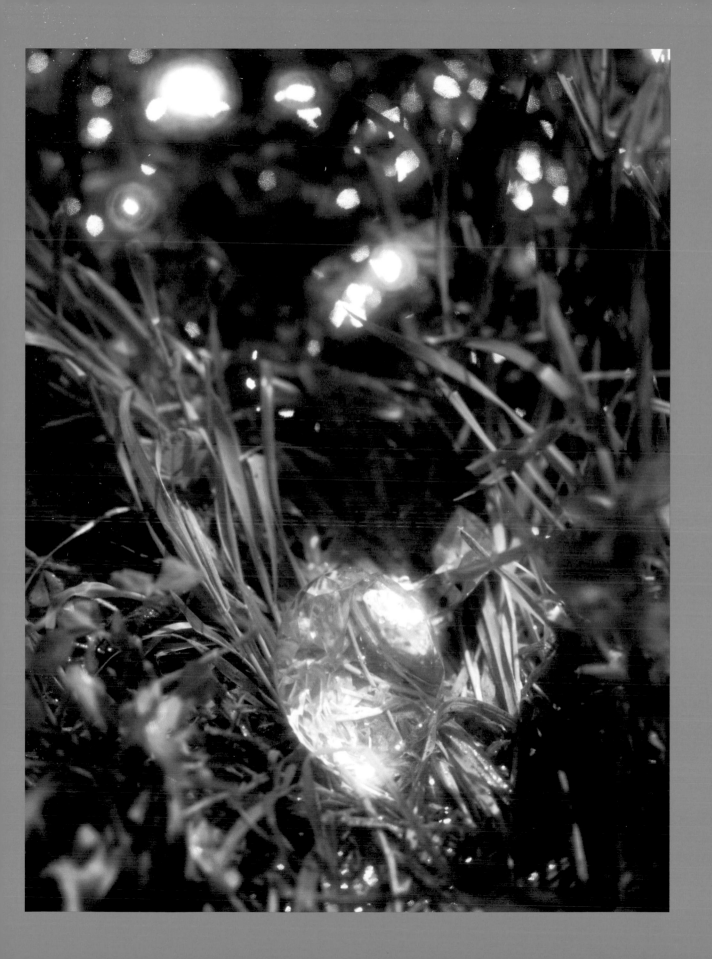

. . . but he loses it to the glistening waters. Reaching down in search of it, he discovers many more: was he the first to lose a diamond in the waters, or had others crossed this way before?

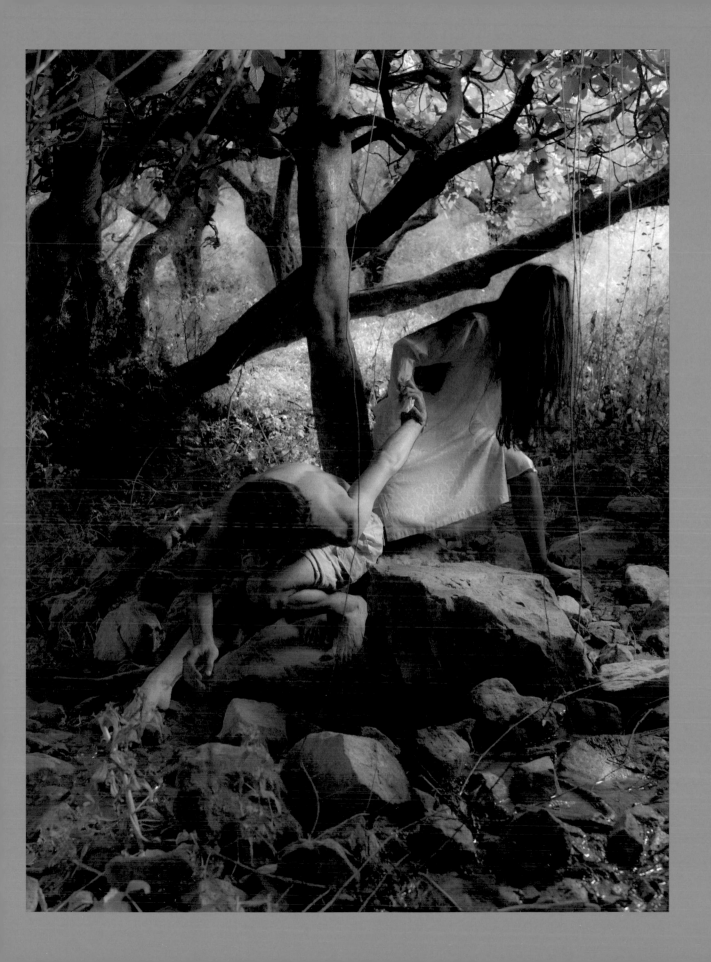

Adam lies interred, his feet still glowing. If you approach a voice rings out: "You have seen of my likeness, but you cannot see my likeness: come no further!"

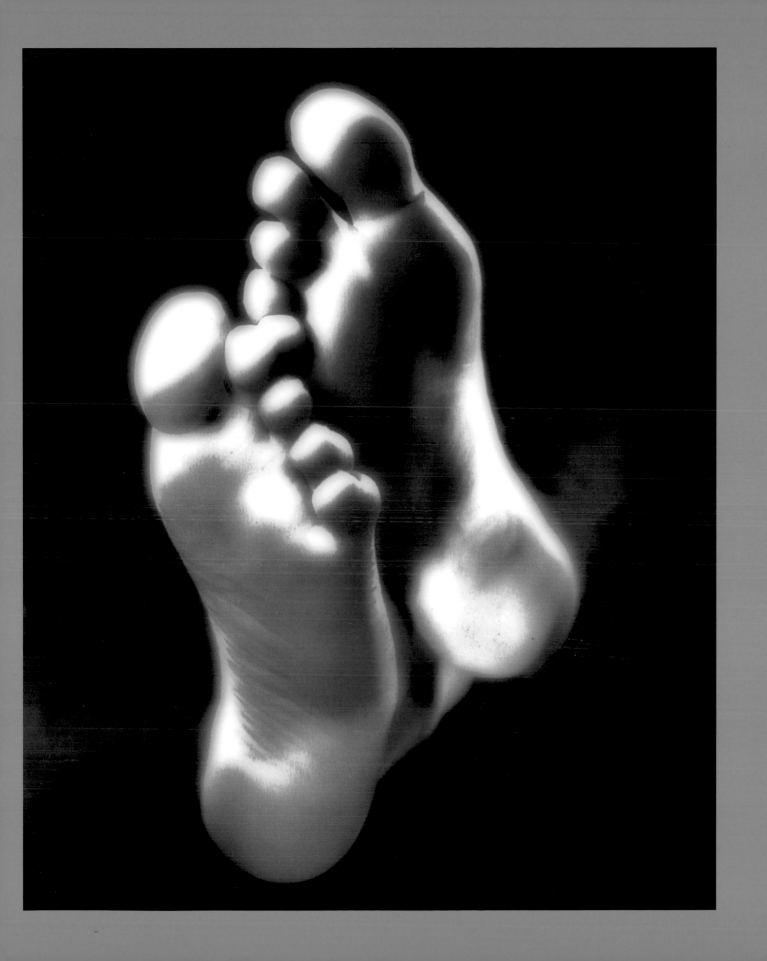

Generations upon generations pass.

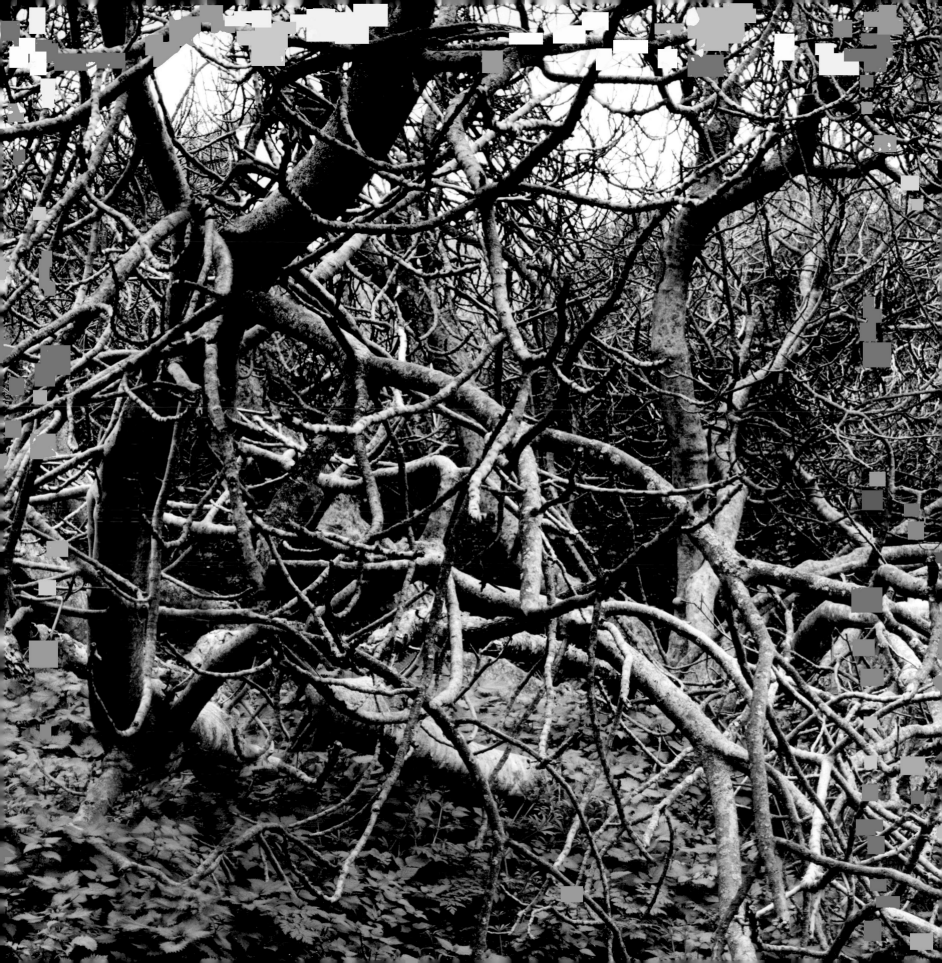

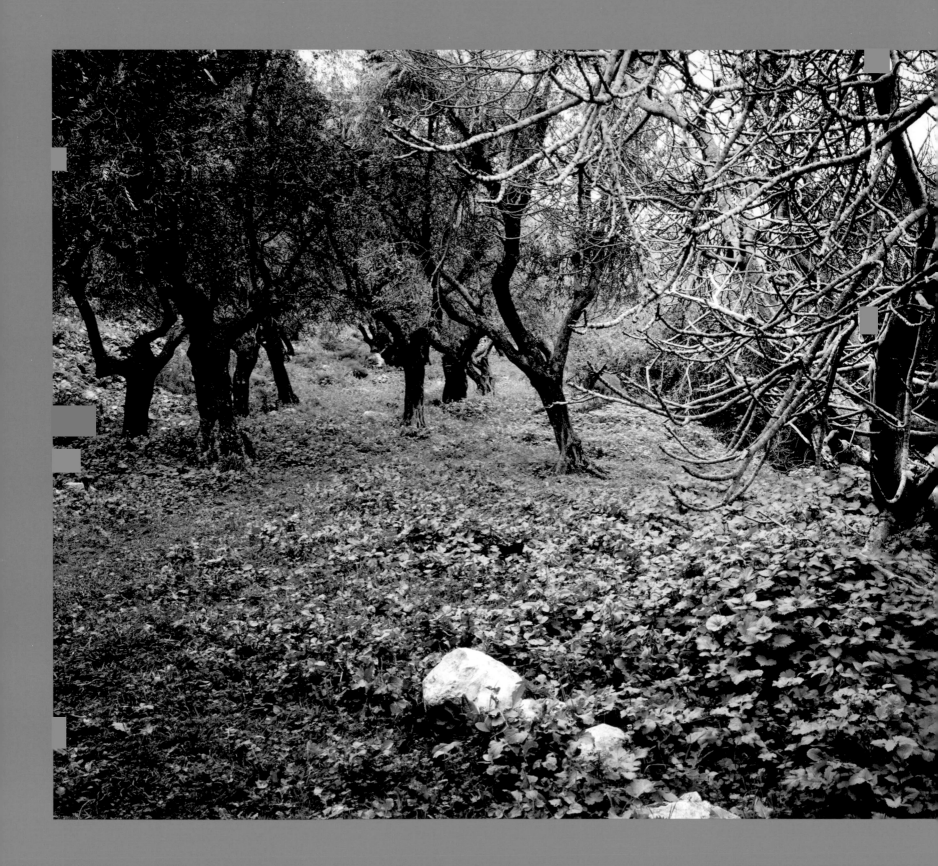

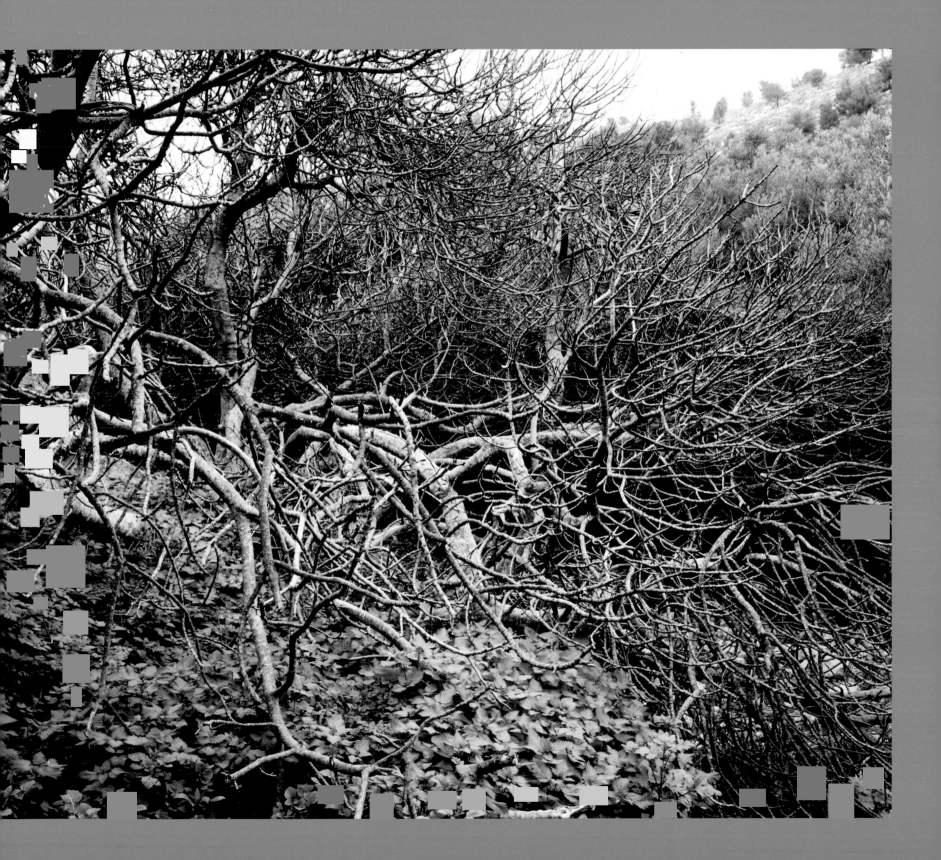

Men and women no longer recognize Eden.

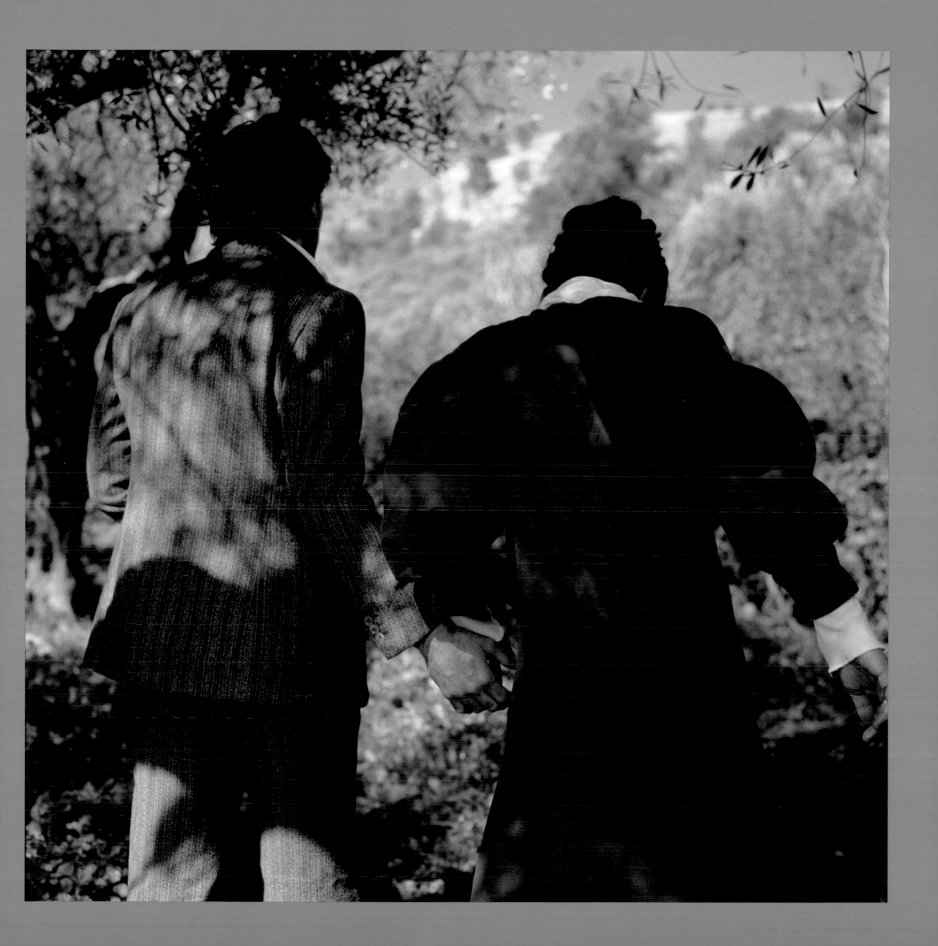

Nor do they feel at ease there.

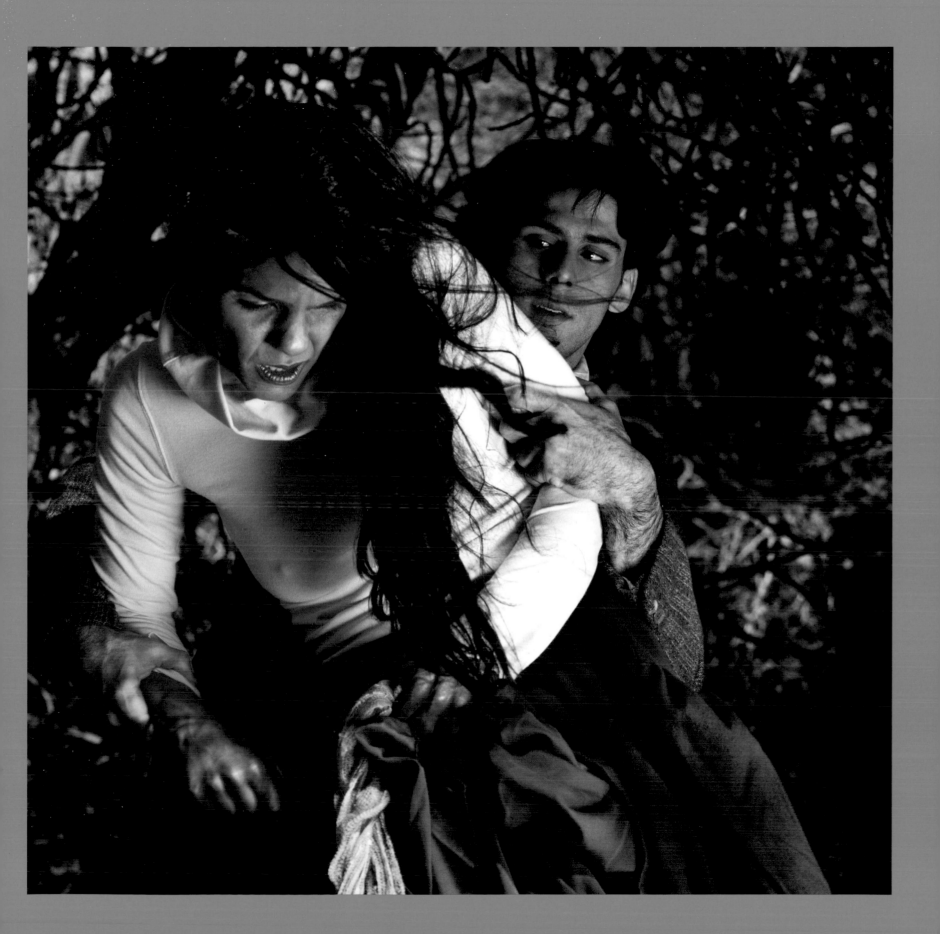

They search for the lost light and seek reconciliation with each other and with the barren trees. If they knew that Eden remains accessible, they might yet find solace.

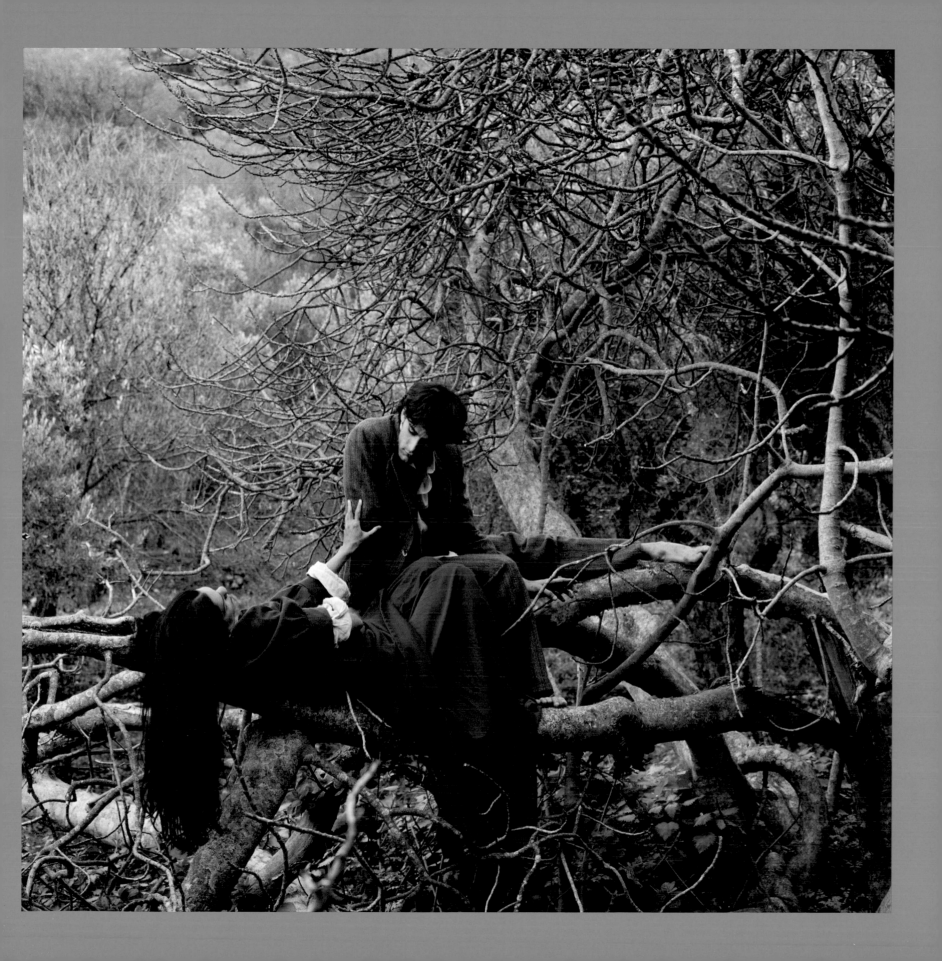

Light years from creation, your ancestral
memory of Eden has dimmed. Only diamonds
clawed from the earth, cut and polished, hint
at the lost radiance.

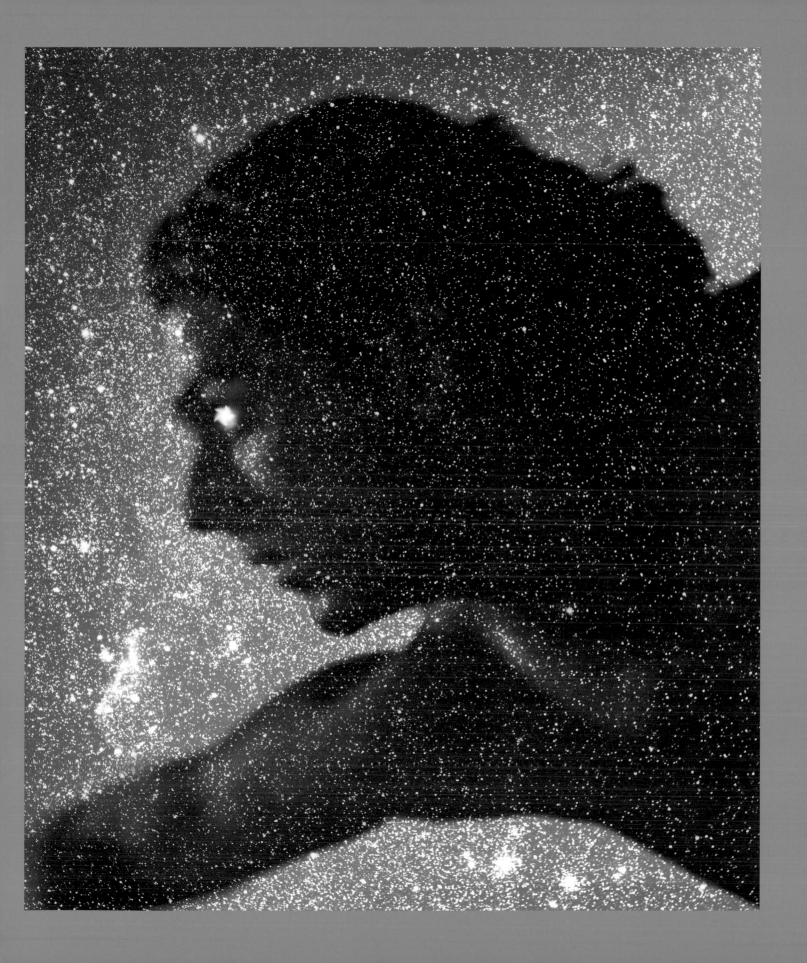

If the pictures that I have made and saved for you all this time resemble things you have seen before, or recall memories long forgotten, then you will understand: you weren't meant to remain immortal. Now as always, for you exile is within and the garden is without; for me, I once tasted perfect sweetness but now only dust. Only my chronicle remains.

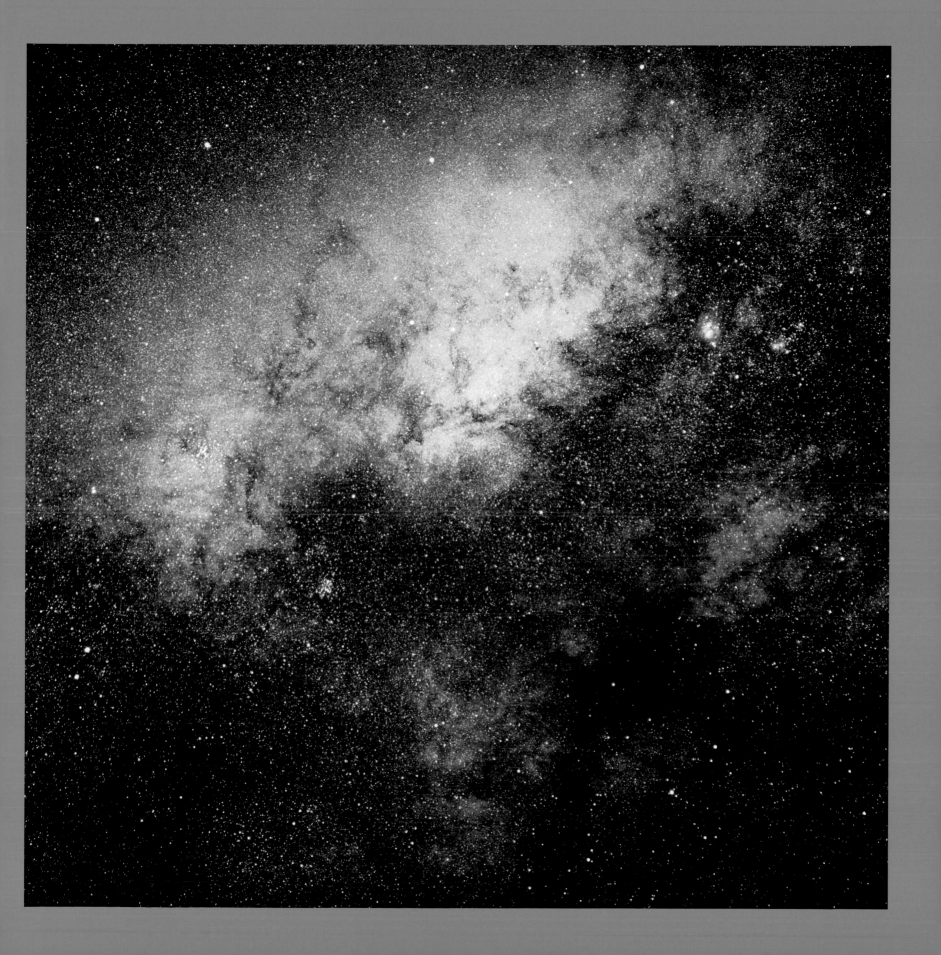

The Story of Adam and Eve Explained

An Interview with Neil Folberg
by Henry Giardina

I hadn't intended to take something quite as iconic or challenging as the story of Adam and Eve—it's crazy to take on a story like that. On the other hand you have the advantage that everybody thinks they know it. This work is a somewhat romantic view of the world. It's not so popular today in the art world. The trend, especially in most post-modernism, is away from stuff with meaning, and I was interested in meaning, in telling a story. For my subject I was looking for those kinds of things that are ambiguous—it's not clear what they are, what they're about, what's going on, if you weren't involved in it you wouldn't know what to make of it—I was looking for a story like that. And I was very familiar with the Jewish oral tradition, which is sort of an oral storytelling tradition that fills in the gaps in the written word in the Bible. This *midrash* encompasses all the things that could have happened, did happen, didn't happen, would have happened—and there's no time, either, there's no past, present or future. Things that we think of as being today could easily be integrated into a story from yesterday, it's just a jumble of time and place and, it's like, if you want to put it in terms of modern cosmology, the idea of having multiple universes or something, that all have a possible existence and we just live on one of them. The moment you make a decision, you move to another universe, because you leave the other universe of all the other possibilities behind you.

The *midrash* asks all those questions that if you're an astute reader you really should ask. For example, if Adam was created alone by himself, how is he going to feel? Every other creature has a mate, and he's by himself. What kind of an idea's that—that's paradise? That's loneliness. It's begging for something to happen. And so somebody else is created for him according to his desire. But once she's there she has her own will. He thinks that she was created for him, but she thinks she was created for herself. So there's going to be conflict immediately—there's going to be a contest of will, who's going to be stronger? It has to be a situation where there's discussion and sometimes conflict. So that's not paradise either, that's struggle. That's what we all do all the time. The moment that you want to accommodate somebody

77

else you have to start making compromises. You look at the story and you read it as some kind of a fairy tale, and then you realize it's about the essence of human relationships.

There are some interesting ideas in this Jewish oral tradition—some of which you'd have trouble reconciling with the text if you didn't know it in Hebrew. For example, the oral tradition which is called the *midrash* says that men and women were created as one creature, two faced—two sides: one side female, one side male. So man and women were created, joined together at the head and then split apart. What does that say, metaphorically? It says that neither one is complete without the other. And that in order to be happy there has to be another kind of unity achieved—and this time it's not a given kind of physical unity but something you have to work at.

Adam thinks, "God told me that I shouldn't eat the fruit of that tree, so if I tell you you shouldn't eat the fruit of that tree, you might be tempted to touch it and smell it, and if you touch it and smell it, you're not going to be able to resist eating it." He gives her different instructions, he says, "If you touch the tree, you'll die." That's not what God told him. This third character, the serpent, hears that and thinks, "All I have to do is show her that if you touch the tree you don't die, and then she won't believe the rest of it either."

And what is this tree? This tree is a tree that gives you knowledge, and what kind of knowledge? You can see generations after generations, you can see the entire history of the world, so if she would eat of that tree, she would be able to see the generations that are going to come from her, she would see the entire history of the world spread out in front of her—and the snake has already been doing this, he already has this knowledge. Man is created innocent—but it's clear that Eden isn't meant to be that way—in other words, they weren't meant to remain innocent, they were meant to get into trouble, they would have to deal with complexity in life. Whatever you do you're going to have to struggle with conflicts—things that you want that you can't have, things that you'd like to achieve that you're unable to, something you would like to be that you can't become. Life is struggle. So this "Garden of Eden" is meant not to be paradise, but sort of a testing ground for learning to deal with failure. It's a story about that—that's something everyone can relate to, because it's our lives. So you think it's a very simple kind of fairy-tale like setting where if you believe it literally then you think that "we've fallen from grace and can never get back," but the truth is we were never meant to be in that state of grace. We were always meant to struggle. And that's the lesson behind the story.

So Eve takes this fig, and she sees all of the history of the world unfolding in front of her—she has now complete knowledge of everything that is and will be. And she also sees that she's going to die. Now she's mortal. Man was created with an immortal aspect—in other words they weren't intended to die and now she's done something and she's going to die.

And as they're forced to flee Eden, an angel comes to them and says, "You have to leave, you can't stay. But if there's something here you really like you can take it with you as a memento, to give you some consolation." And what's remarkable about Eden and

its idyllic state is the light—it's pervaded with this spiritual light that illuminates and brings understanding. Nothing is hidden. In Eden, everything is understood at least on an intuitive level. But in our world, we don't really understand what happens around us. You know if we live in a city we think the world is under our control and the universe is more or less understandable, this is a human environment. But every once in a while sometimes something vast or disastrous happens, like unfortunately what just happened now in Japan and then we realize our lives are not under control, that there's something beyond us, there are forces that are greater than we are. And that we haven't got control over everything. But they didn't feel that, they saw this light. And so he sees diamonds scattered around Eden, and so he says, "I'll take one of those because it has the light refracted, it's the essence of the light—anytime I look at that diamond I can see beauty and wonder and know that there's something beyond whatever physical difficulties I'm having now. And so he picks up the diamond, and they start running, they have to flee. And as they cross the river he drops the diamond in the river, and he bends down, she's running, and he reaches down for it and he finds not one diamond but many, and he's shocked—he looks at the angel, and the angel says, "Did you think you were the only one? Did you think you were the first? There were thousands before you, they all took diamonds, and they all lost them in the river."

He's not even longing for the thing itself, the light—he's only longing for the remembrance of the light. All he wants is the memory, and you can't even have that, you can't take it with you. Every once in a while in your life you get a glimpse of that kind of light—you can see something and for a moment it happens—it happens to artists, it happens to people who think, to people who are sensitive, to people who are spiritual—under certain circumstances you sometimes get a glimpse of something beyond you and you feel for a moment that you really understand the universe and your place in it. It's not knowledge, it's just a feeling. You can make it last, you can talk about it for the rest of your life, you can forget about it and move on, you can do anything, but there are those moments where sometimes you get a glimpse of something bigger than yourself, and that's what he wants. But you can't take it with you.

Afterword

By Allen Hoffman

Once again we are welcomed to the Garden of Eden with its celebrated fruit tree. Our instinctive reaction might well be "been there, done that," but such a jaded response would be inappropriate because in the *Serpent's Chronicle*, Neil Folberg has crafted a very imaginative, provocative retelling of the primal biblical myth of Adam and Eve's sin and their punishment, expulsion from the Garden. Myth is obvious and myth is a mystery. In the *Serpent's Chronicle*, Folberg attempts to demystify the mystery of why Adam and Eve ate the forbidden fruit. His answer is that Adam and Eve never really had a choice: *you will understand; you weren't meant to remain immortal,* the *Serpent's Chronicle* concludes. We are told earlier, *Life is a trap, a trick; Eden a dream.* They never stood a chance.

Folberg's reading of the myth is based upon a classic midrashic interpretion that internalizes and humanizes the opening chapters of *Genesis*, but the *midrash* provides only a brief, undeveloped comment; it does not suggest any textual changes. Such a humanized reading demands that the biblical text be interpreted as a psychological tale, revealing our internal human desires and intellect as motivating the plot. If myth is to retain its primal power, however, it must remain obvious. In an extraordinary bold stroke of the literary imagination, Folberg rewrites the biblical myth to clearly substantiate his humanized reading. The Serpent receives both literary and moral upgrades as he becomes a reliable, passive but highly knowledgeable narrator and not a satanic instigator. And, modest, too; he cannot be seen. No human, neither Adam nor Eve nor any reader of the *Chronicle*, can see him. No longer the lowdown varmint in Genesis, he is sympathetic to Eden's couple and so empathetic to their offspring, the human race, that he has graciously saved photographs that exonerate the hapless sinners. Adam and Eve also receive a moral upgrade: they are not outrageous violators of the Divine Will, but ordinary folk responding to an impossible situation. If there is an upgrade, alas, there must be a concomitant downgrade. The Creator, the Deity, has disappeared altogether. Indeed, He is no longer the author, and the text is now the *Serpent's Chronicle* told to us by our ordinary garden-variety demiurge. Not only is there no Deity present, but being a Deity isn't what it used to be. Having eaten from the tree, the Serpent has the power to see all of history, a powerful skill, but hardly comparable to those of his Creator. Although immortal, most of the Serpent's eternal days are spent curating the scrapbook photos he has saved for the descendants of Adam and Eve, his old down-home neighbors.

And so our graphic tale begins, and there is a surprise. If the text of the *Serpent's Chronicle* is not familiar, the pictures, at first glance, are very familiar. Adam and Eve seem to be a young, pleasant couple just like any contestants you might meet on a reality TV show featuring survivors. But something strange occurs as we proceed through the Garden. The photos are anything but ordinary. As we proceed from text to picture, from Garden to Adam to Eve, we are told what we should see, but we see more. Magic occurs. What we see in Folberg's photos exceeds the text. What we see reveals growth, radiance, lust, love, rejection, renewal—all mysteries. Hearing is understanding, but seeing is believing. And what do we believe when the black-and-white figures of Adam and Eve "reunite" in an earthly-unearthly archetypal majestic modesty—sensual, sublime, and sepulchral? We believe that we have been tricked, and we should have known better, because we have been twice warned. These are the pictures of a creature who described himself as *sinuous in sorcery* and who introduced himself as a *snake in the grass*. We want to believe the *Serpent's Chronicle*, but things are not so simple when we see myth illustrated and we experience myth mysterious. We believe in the art of Folberg's garden because there is sorcery in his photos. We leave his garden exiled, but ennobled by his appreciation of and his desire to understand Creation.

List of Plates

All works 2009

For Lin

Adam: Shai Partush
Eve: Renana Rendi
Dancers courtesy of Kibbutz Contemporary Dance Company,
 with the assistance of Rami Be'er, artistic director
Costumes: Kibbutz Contemporary Dance Company and Neta Ramon
Make-up: Smadar
Lighting: Max Richardson

Text editor: Allen Hoffman
Designer: Misha Beletsky

Photographed in Rosh Pina, Israel

Serpent's Chronicle is also available on the iBookstore (ISBN 978-0-7892-6034-5).

Limited-edition prints of the images in this book are available from:
Flomenhaft Gallery, New York
Holden Luntz Gallery, Palm Beach
Vision/Neil Folberg Gallery, Jerusalem

The interview by Henry Giardina on pp. 77–79 first appeared in *Bullett* magazine
on April 25, 2011. All rights reserved; used by permission.
http://www.bullettmedia.com/article/photographer-neil-folberg/

First edition
10 9 8 7 6 5 4 3 2 1

ISBN 978-0-7892-1138-5

Library of Congress Cataloging-in-Publication Data available upon request

For bulk and premium sales and for text adoption procedures, write to Customer
Service Manager, Abbeville Press, 137 Varick Street, New York, NY 10013, or call
1-800-ARTBOOK.

Visit Abbeville Press online at www.abbeville.com.